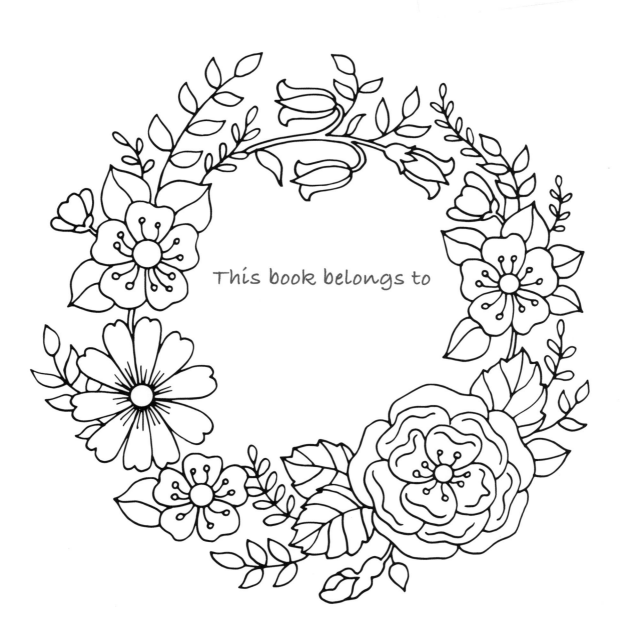

This book belongs to

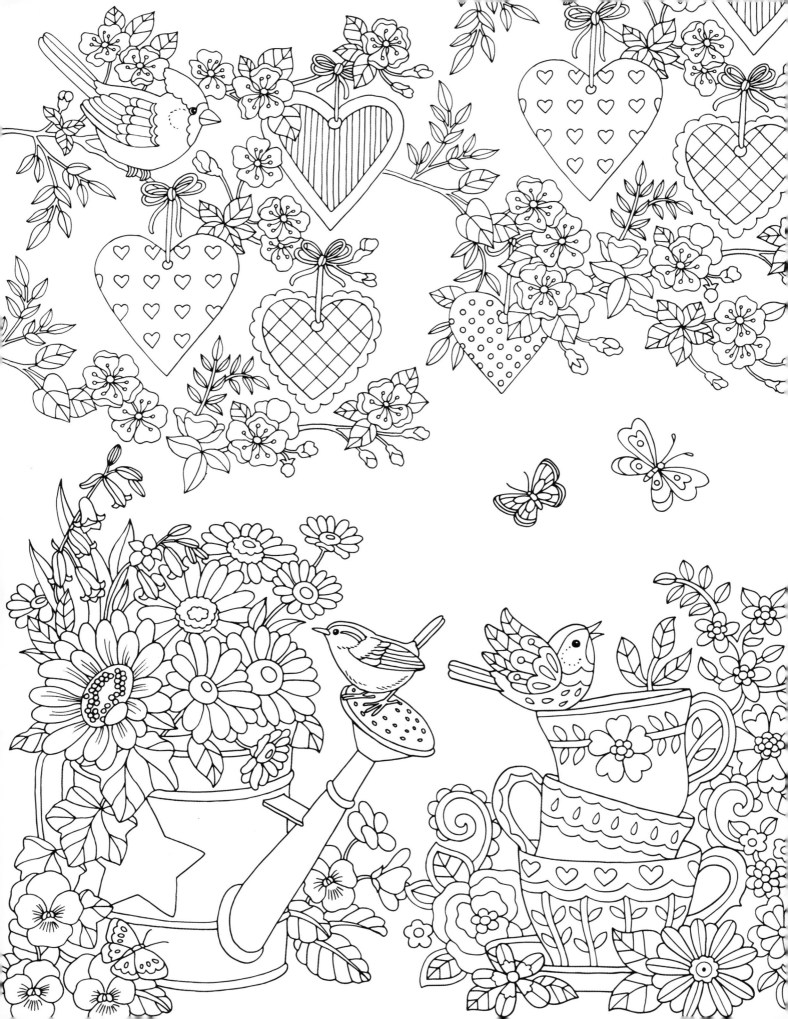

Nature's Sweet Moments

50+ Super Cute Designs to Color

JANE MADAY

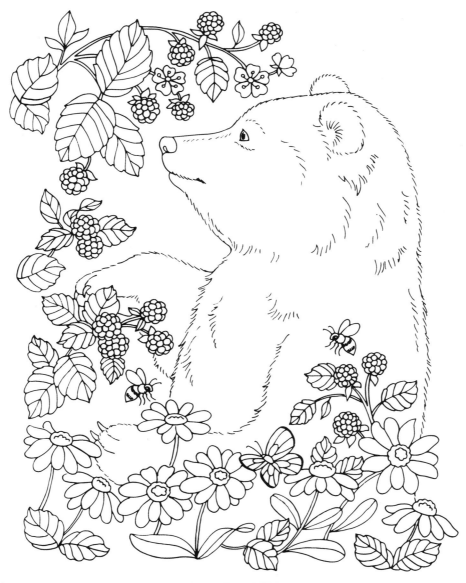

Get Creative 6

New York

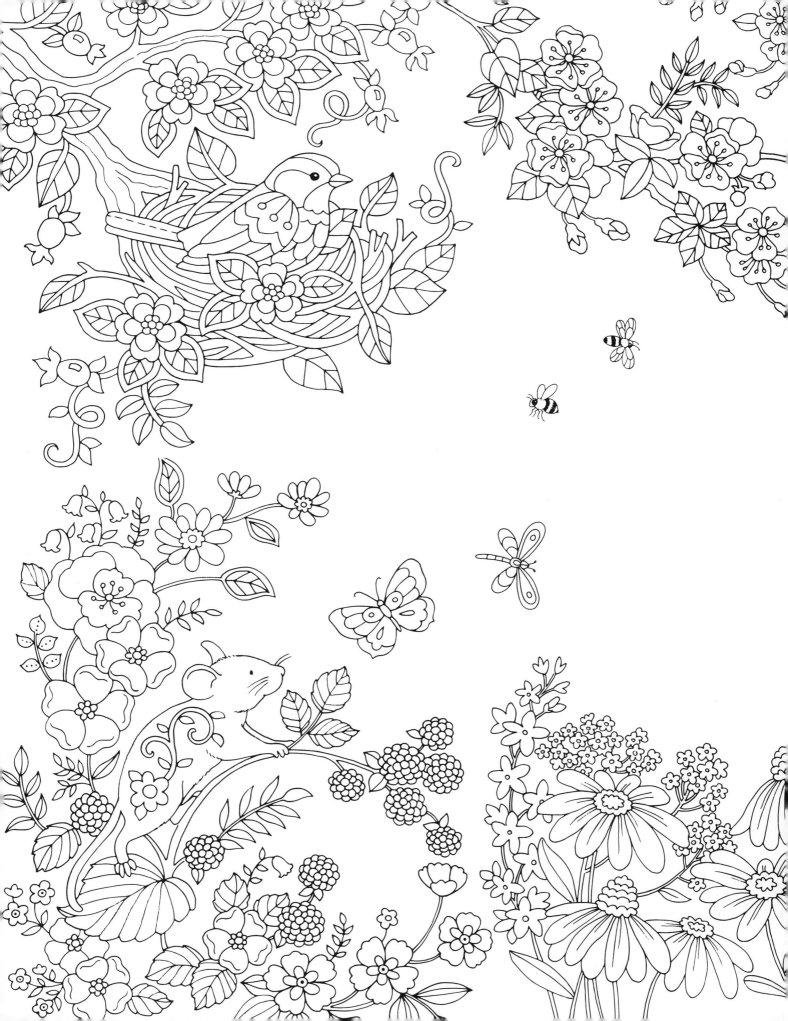

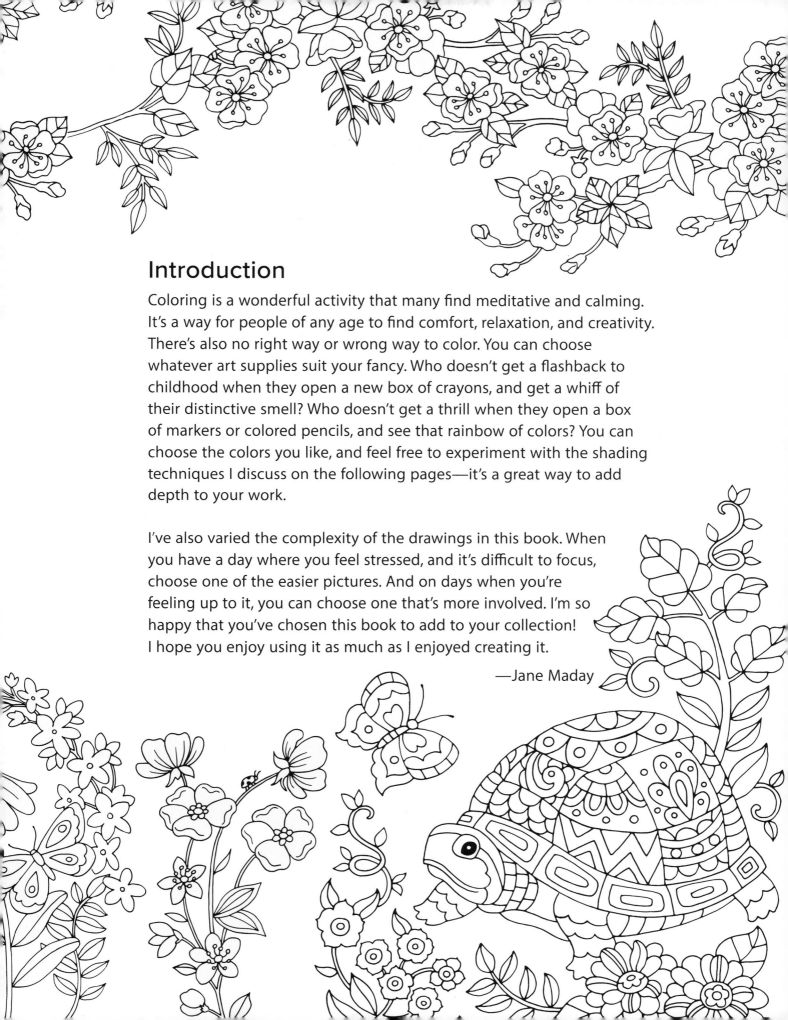

Introduction

Coloring is a wonderful activity that many find meditative and calming. It's a way for people of any age to find comfort, relaxation, and creativity. There's also no right way or wrong way to color. You can choose whatever art supplies suit your fancy. Who doesn't get a flashback to childhood when they open a new box of crayons, and get a whiff of their distinctive smell? Who doesn't get a thrill when they open a box of markers or colored pencils, and see that rainbow of colors? You can choose the colors you like, and feel free to experiment with the shading techniques I discuss on the following pages—it's a great way to add depth to your work.

I've also varied the complexity of the drawings in this book. When you have a day where you feel stressed, and it's difficult to focus, choose one of the easier pictures. And on days when you're feeling up to it, you can choose one that's more involved. I'm so happy that you've chosen this book to add to your collection! I hope you enjoy using it as much as I enjoyed creating it.

—Jane Maday

Tools and Materials

These are some of my favorites, but you might find others you prefer.

Colored Pencils

Colored pencils come in many types from quite hard (good for detailed coloring) to very soft (good for layering, blending and shading larger areas). My favorites are in the middle range.

Crayons

There's nothing wrong with good old crayons. Sometimes, going back to childhood favorites can be a relaxing and comforting experience. Just for fun, I like to use water-soluble crayons sometimes.

Gel Pens

Gel pens are a type of paint pen good for small areas or adding your own details. Gel pens and markers work well together, as you can use markers to color large areas and gel pens for details.

Watercolor Markers

Watercolor markers with brush tips work just like paintbrushes and rarely bleed through paper, unless it is quite thin. Water based markers (different from watercolor markers) often have a bullet-shaped tip. Use these with caution, because in my experience, they tend to tear up the paper quite quickly.

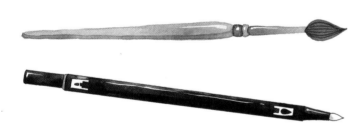

Blending Tools

I like to have blending tools in my arsenal. For watercolor markers or water-soluble pencils, you want a medium-size round brush with a good point for small areas. Buy a proper artist's watercolor brush, as those made for kids don't hold much water or come to a good point. Blending pens are markers with a solvent inside instead of color. Choose one with a fairly soft tip. If the tip is too hard, there's a risk it will roughen up the paper surface. For both these tools, you don't need to apply much pressure. A delicate stroke is best.

Alcohol Markers

These will bleed through almost any paper. However, they come in a wide variety of colors, and blend very smoothly. Be sure to put a protective sheet under any page you are coloring with them.

Shading

Shading is a great way to add depth to your coloring. My favorite method is to color the base color with a marker, then shade it with one or two darker colored pencils. You can also buy blending pens for either markers or colored pencils that help make a smooth blend.

Markers with Colored Pencil Shading

1. Color the flower with yellow and brown markers (either alcohol or watercolor markers). Alcohol markers will bleed through, so put a scrap paper sheet underneath.

2. Choose darker tones of colored pencils, and add shading on the petals, making your strokes go outward from the center. Shade the bottom of the flower center with dark brown.

3. Blend with a colorless blender pen. Your strokes should go out from the center.

Watercolor Markers

1. Color the flowers with your base colors, in this case yellow for the center and light blue for the petals.

2. Choose darker tones for adding shading. Your strokes should be light and go outward from the center. If you release your pressure at the end of each stroke, the stroke will taper.

3. Blend with a colorless blender pen or damp brush (not too wet, or your paper will buckle). Use very light strokes, or you might end up picking up too much of the pigment.

Water Soluble Colored Pencils

1. Color the flowers with your base colors, in this case yellow for the center and pink for the petals.

2. Choose darker tones for adding shading. For a smoother effect, use soft, circular strokes. Do not press too hard, or you will burnish the paper (which can result in a shiny quality).

3. Using a damp brush and feather-light strokes, blend the colors. Your brush should not be sopping wet, and your strokes should be light, or you will lift too much of the pigment.

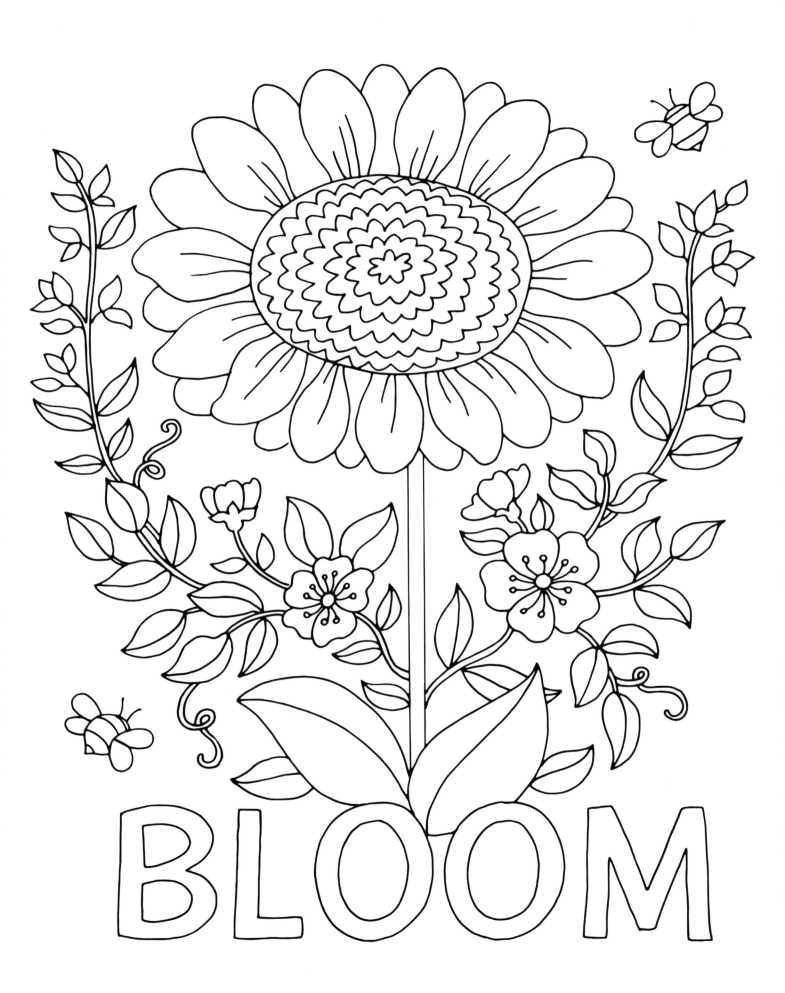

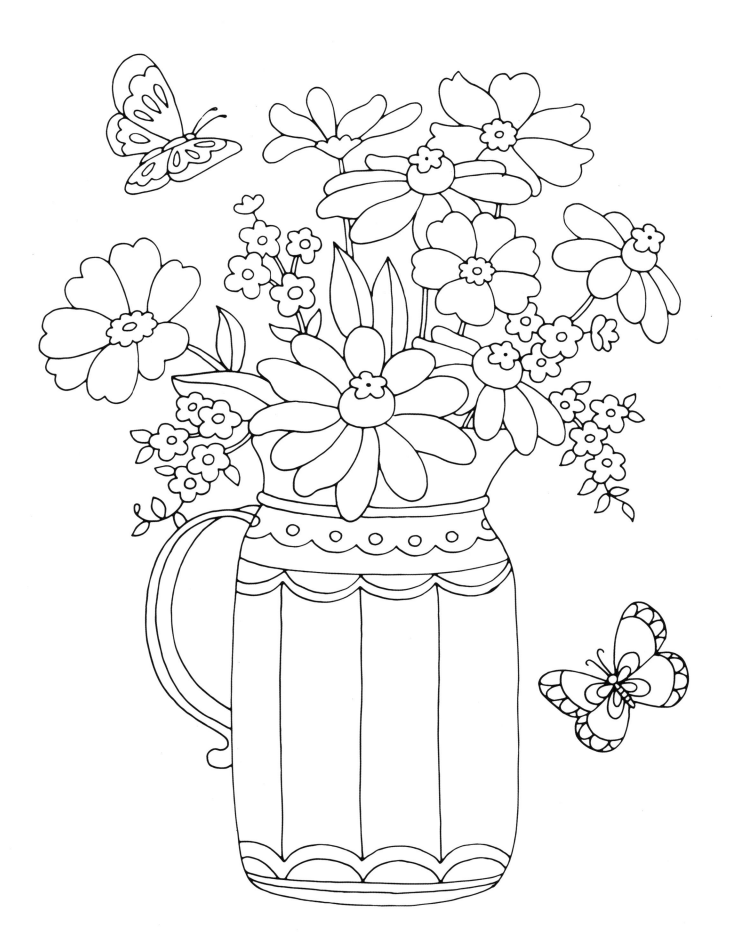

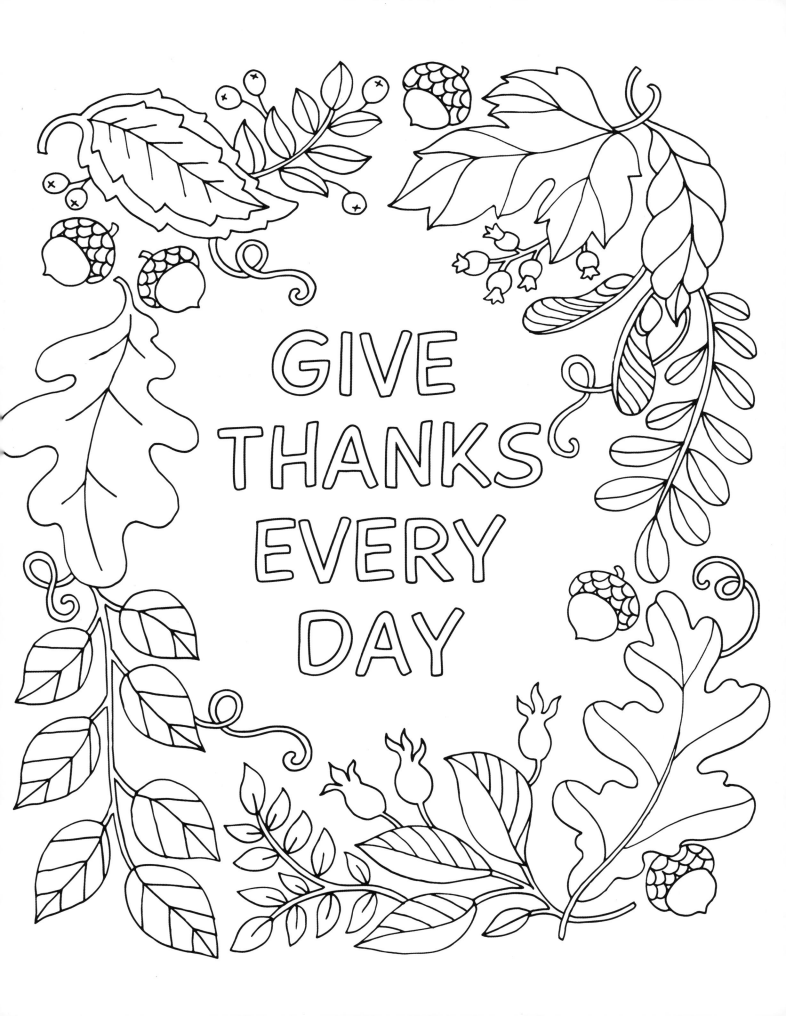

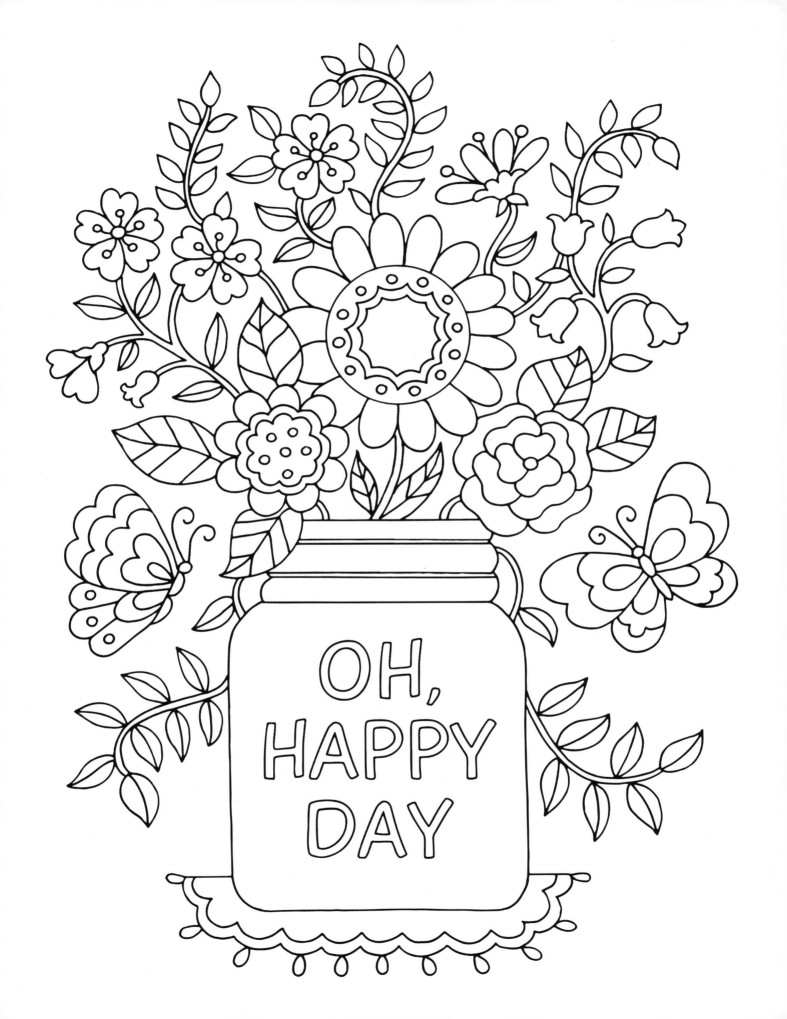

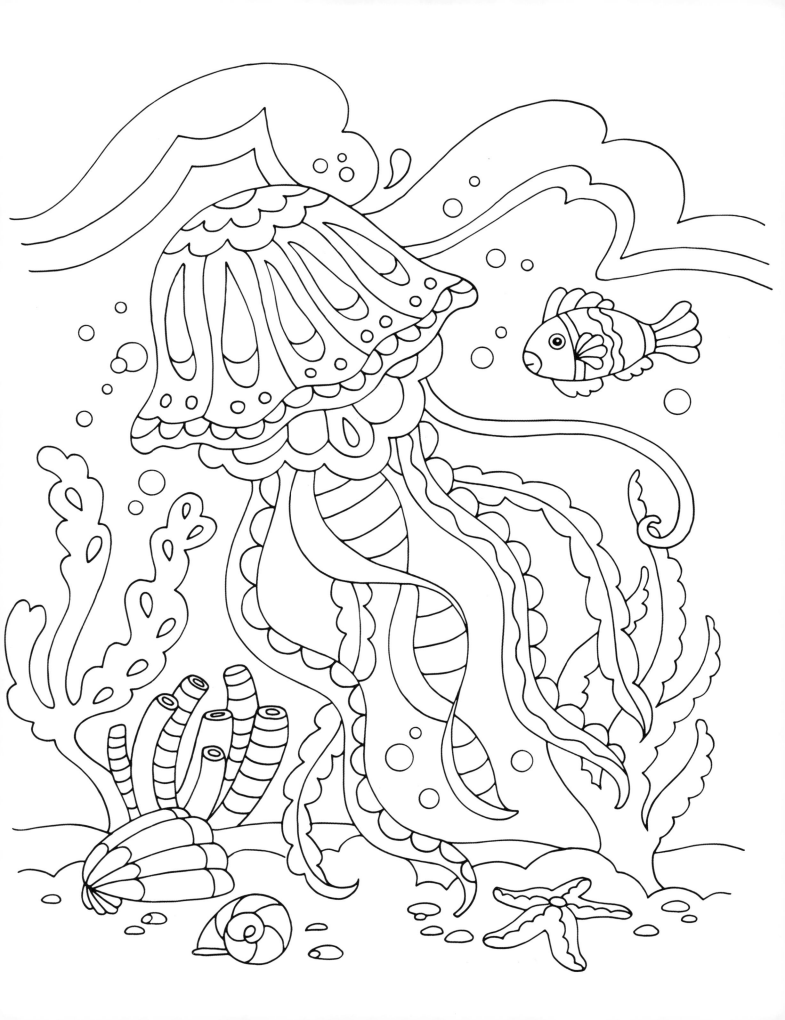

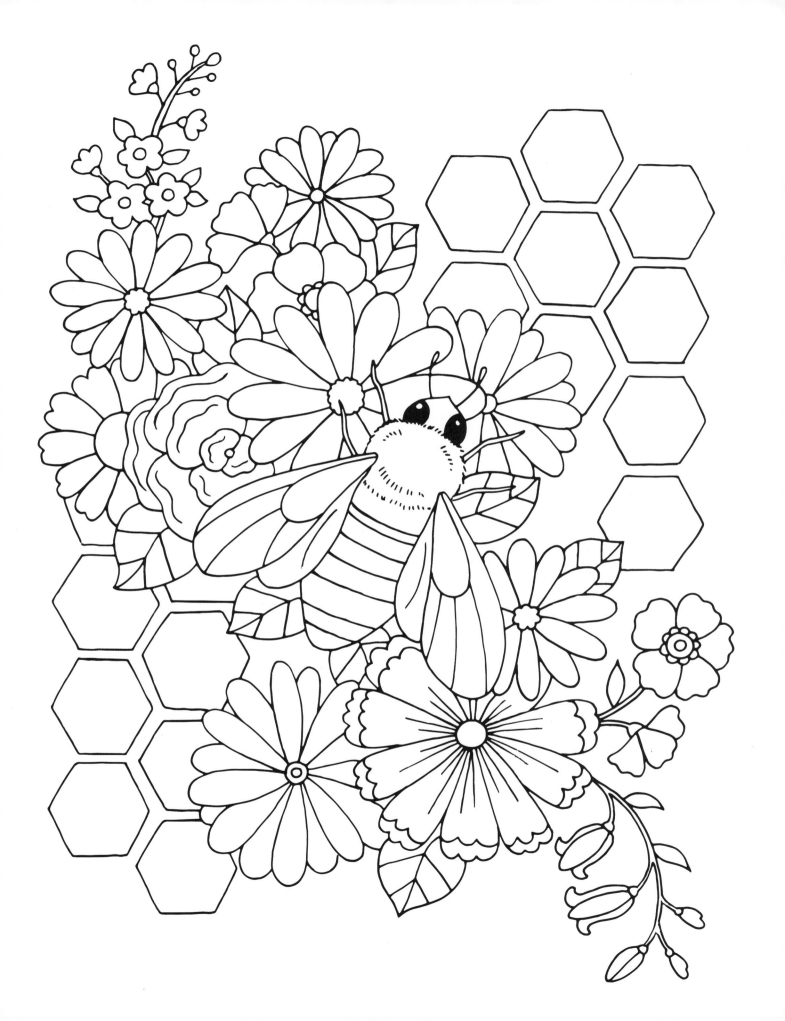

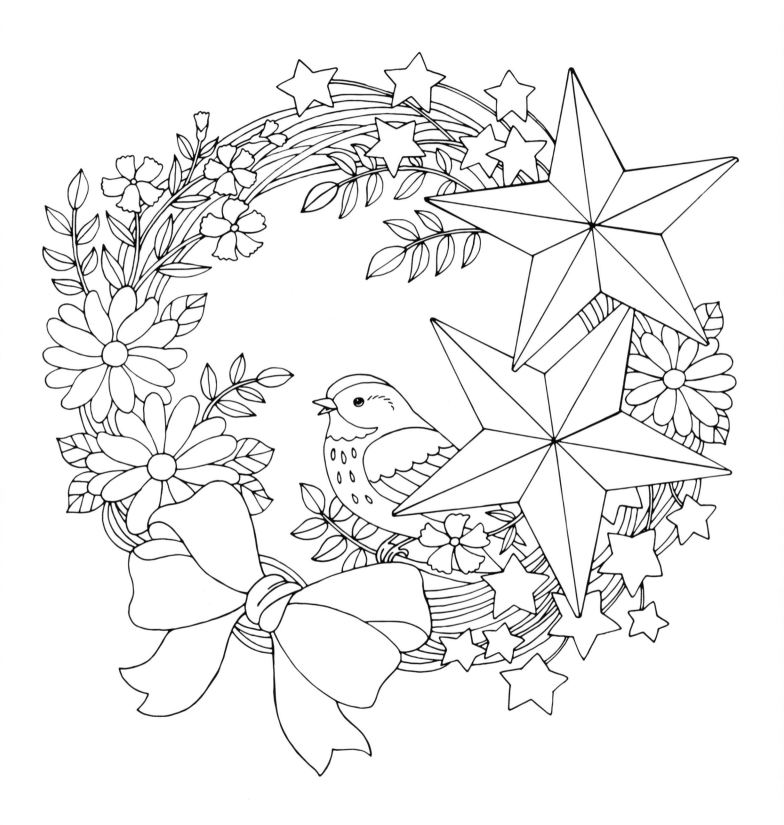

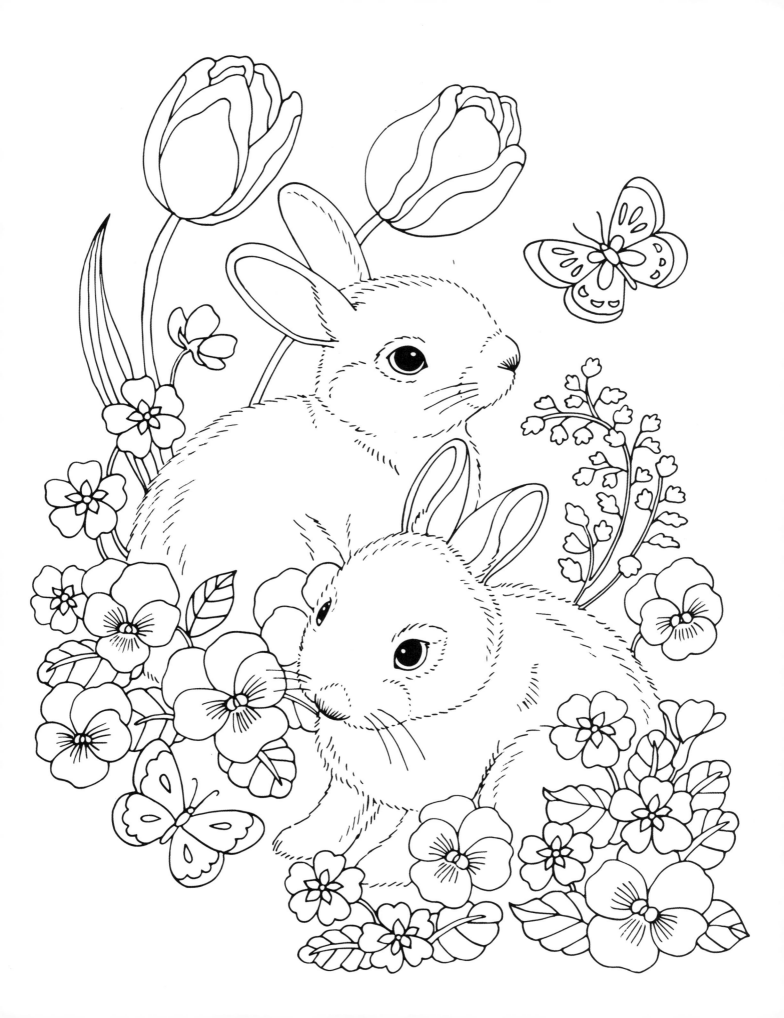

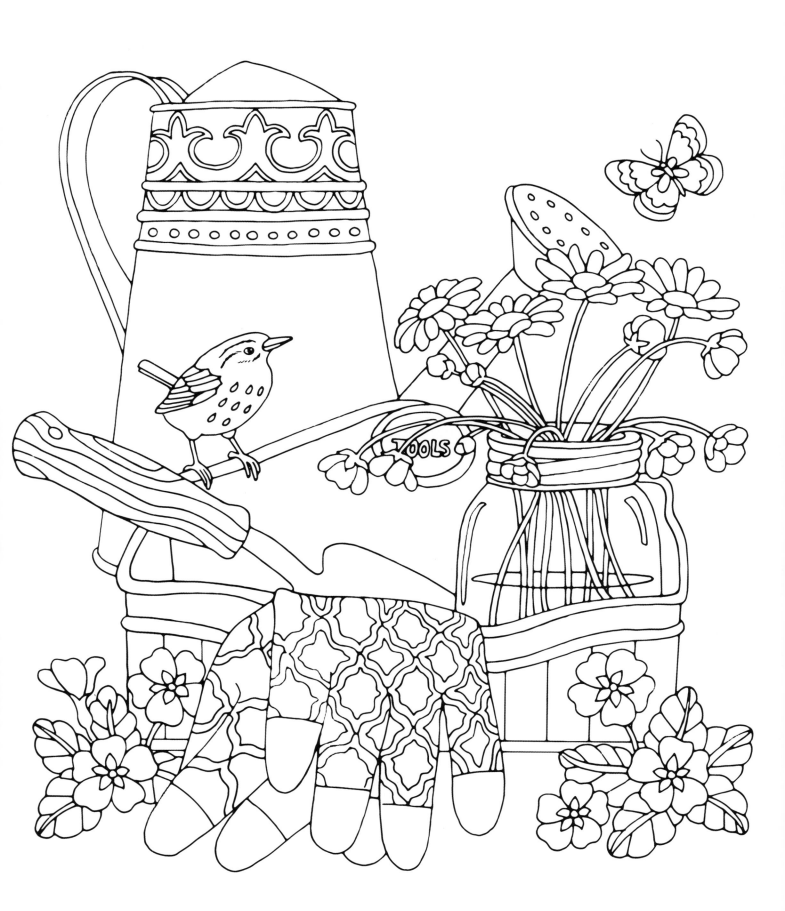

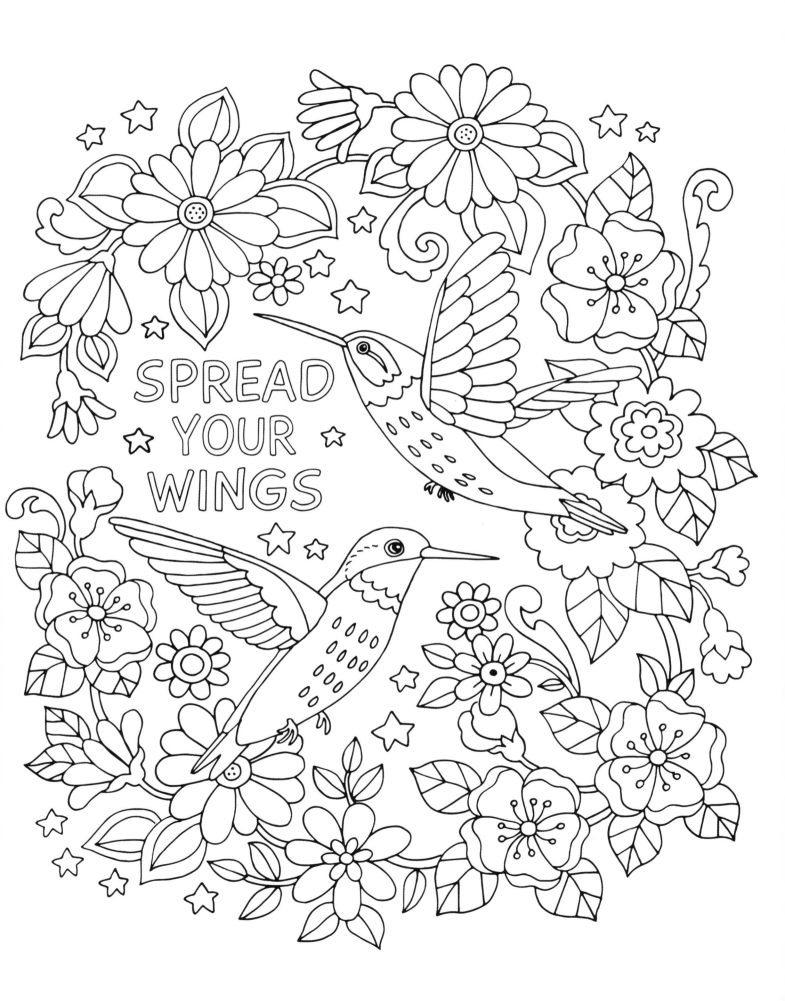

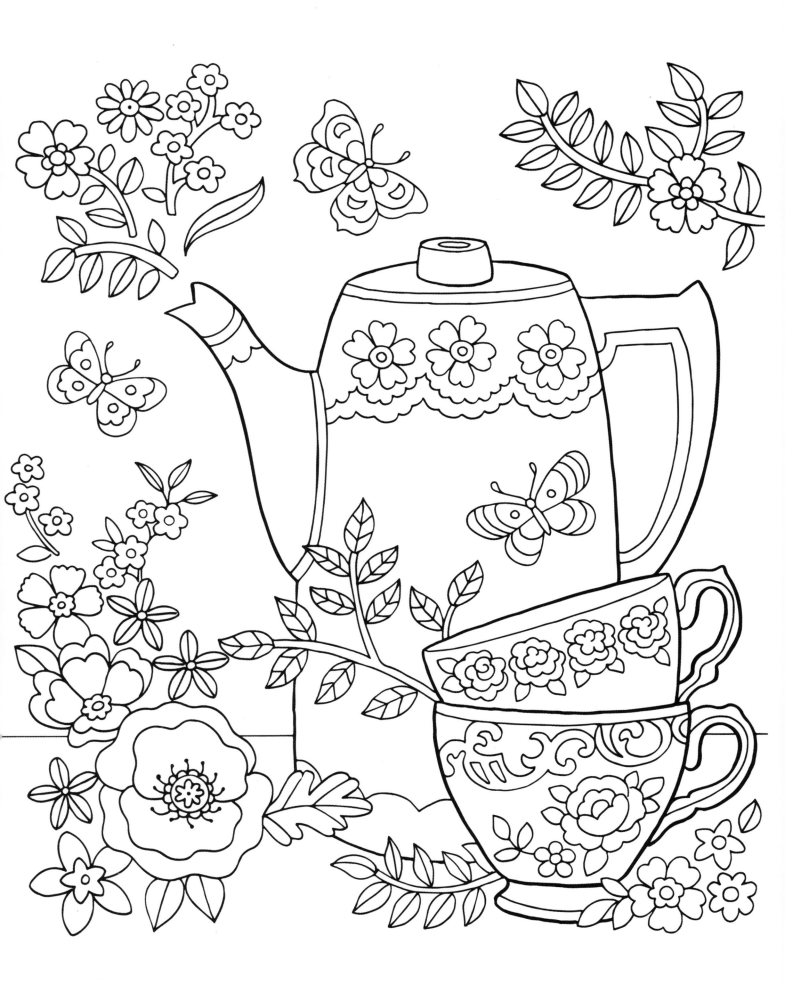

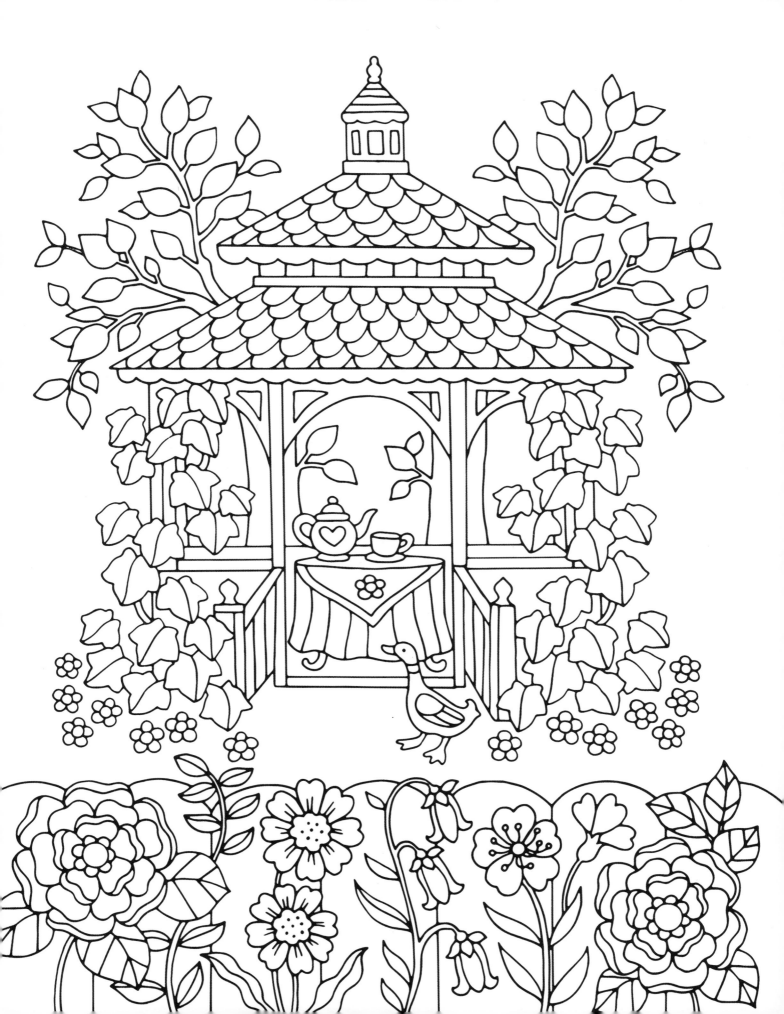

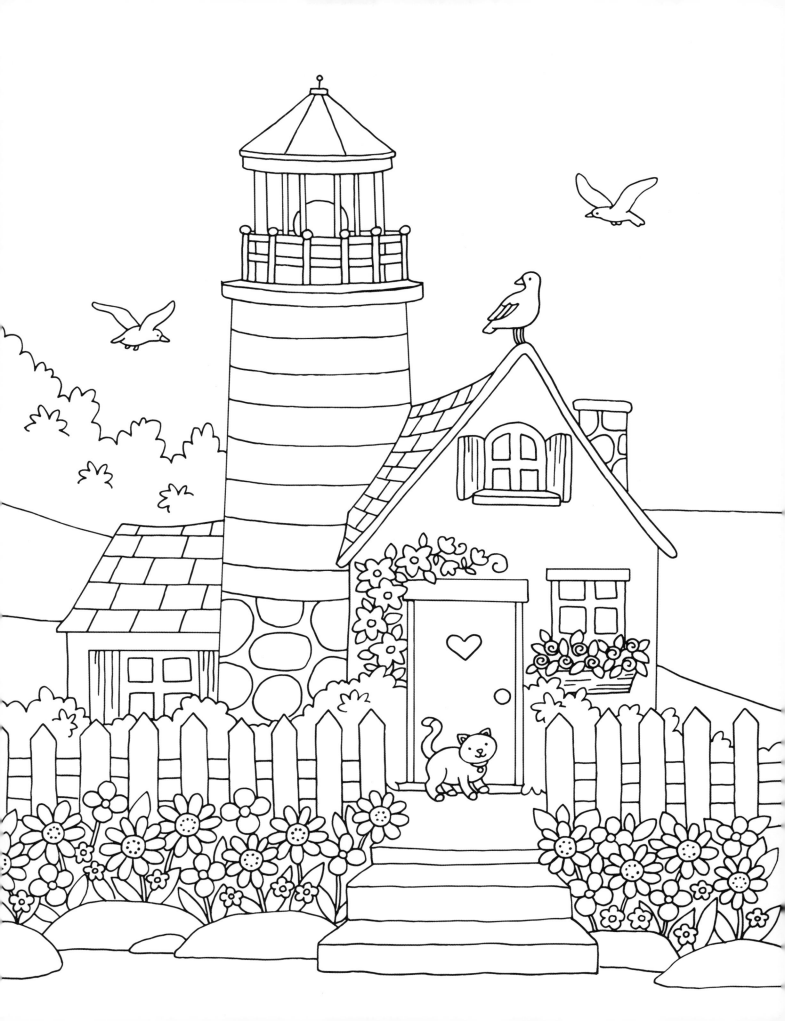

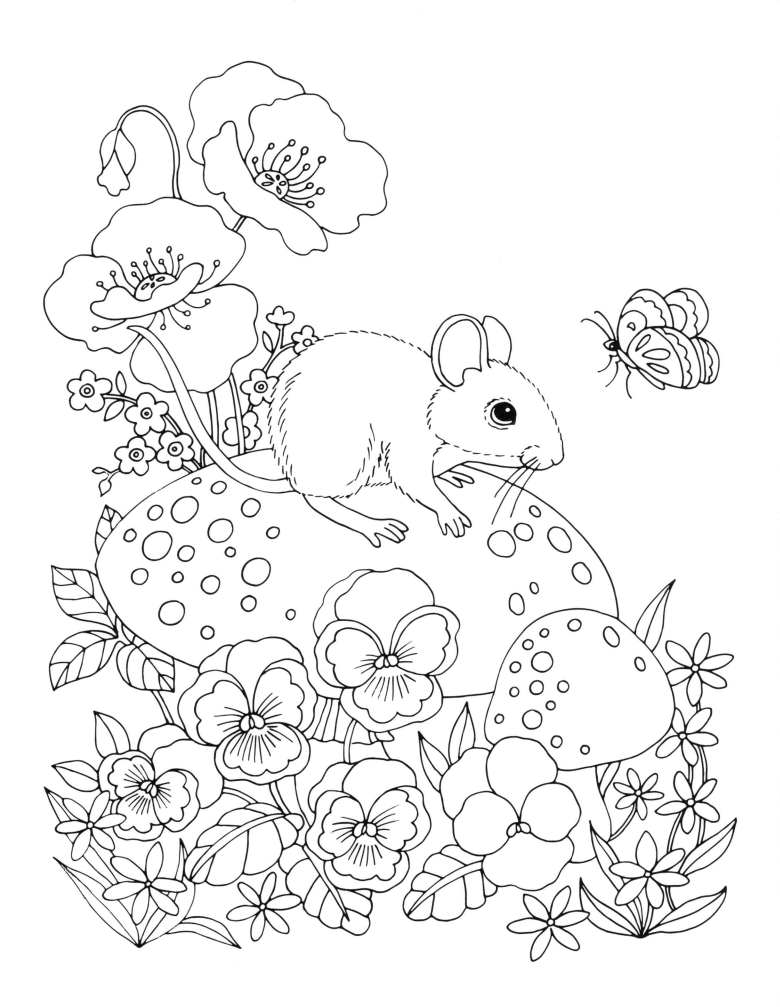

Ride your bike

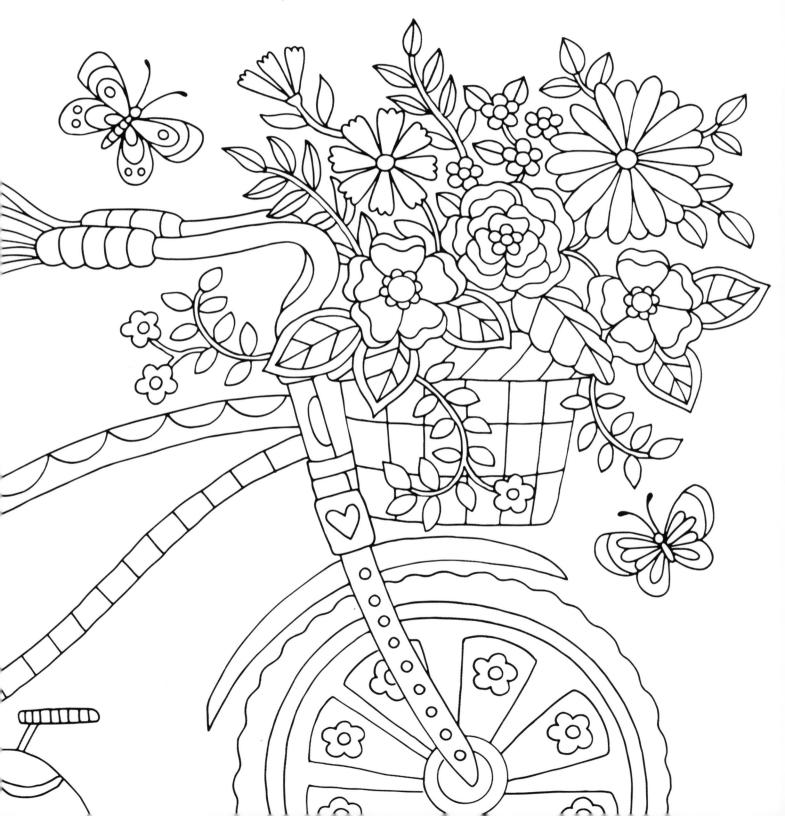

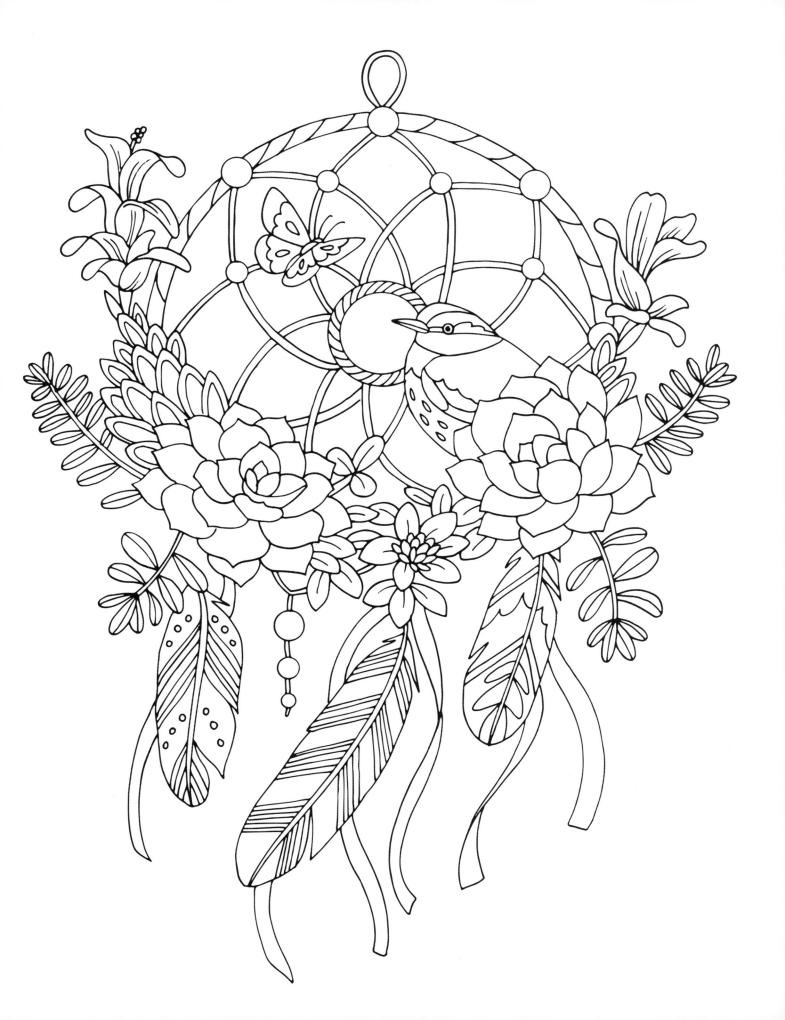

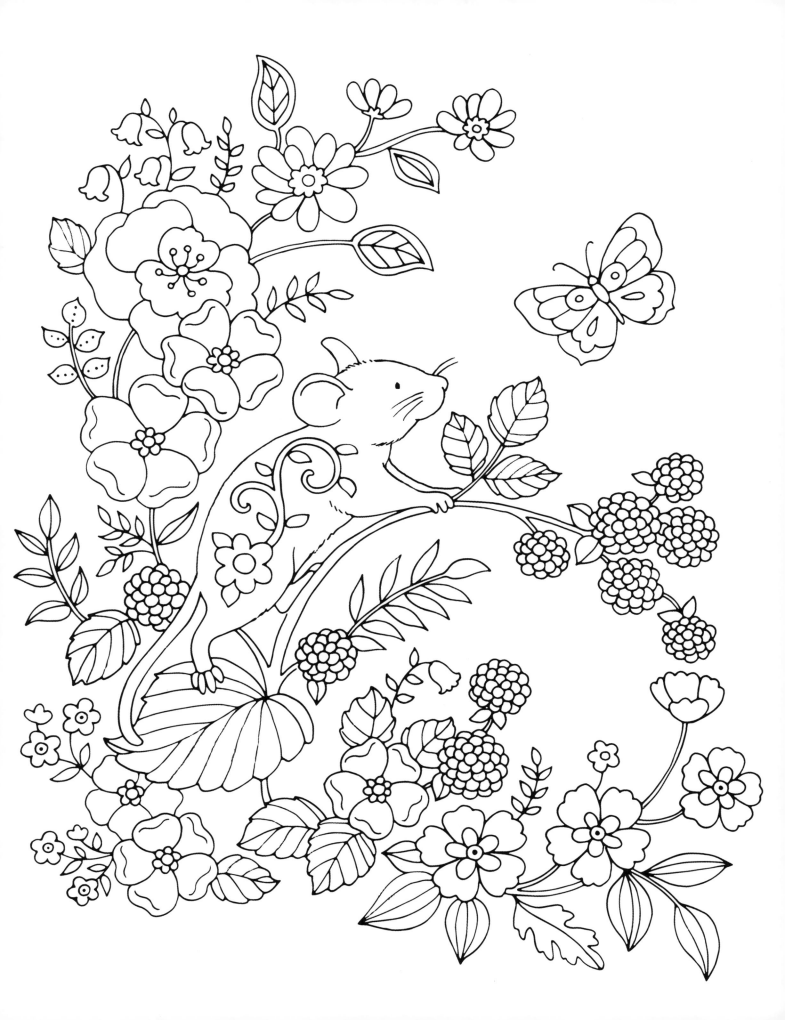

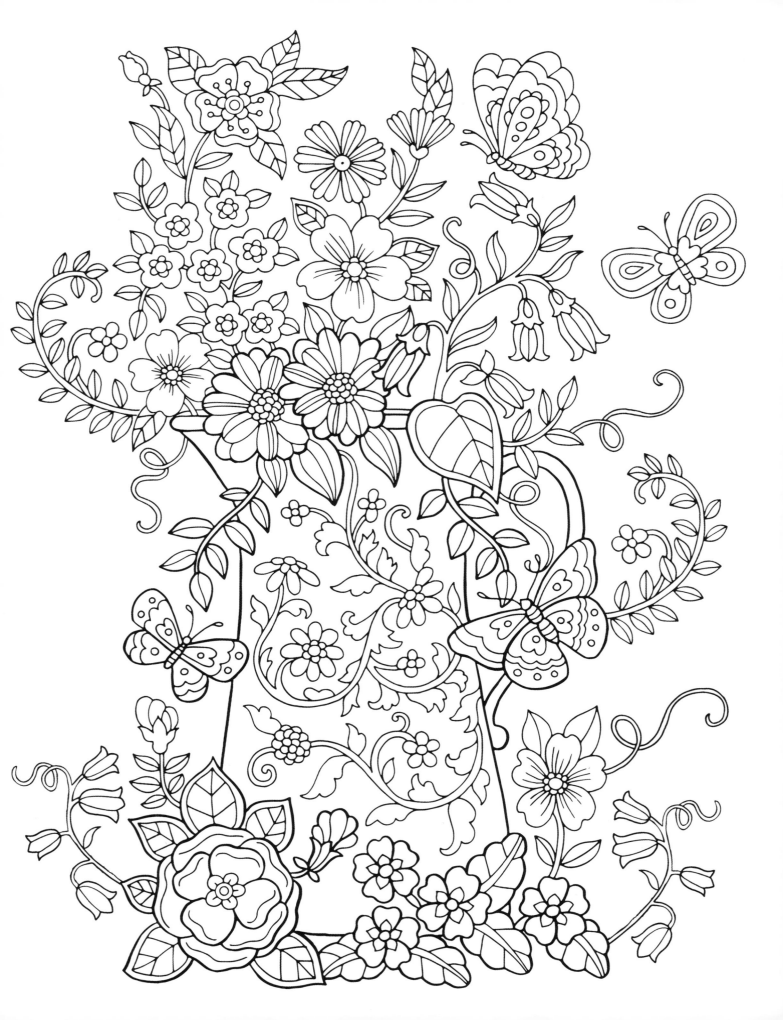

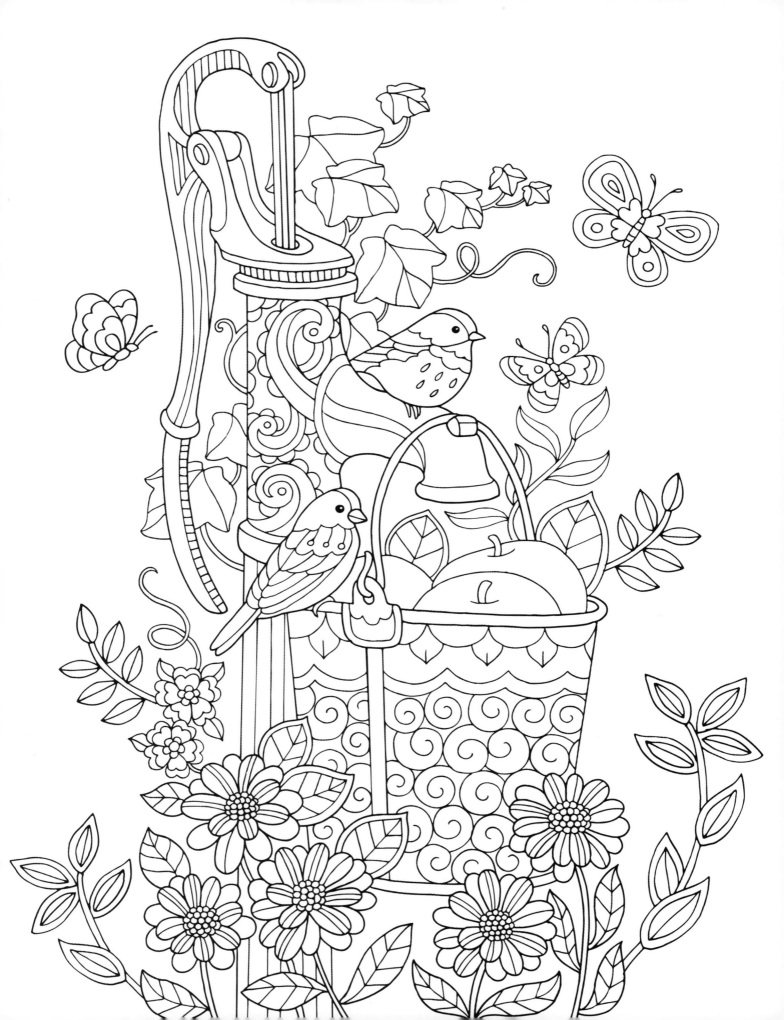

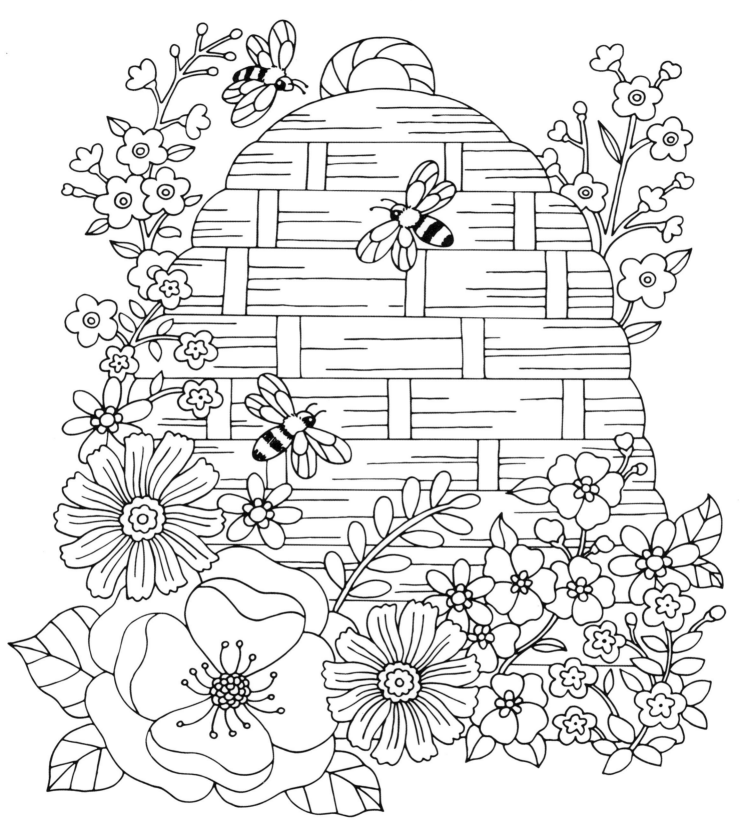

LIFE IS SWEET

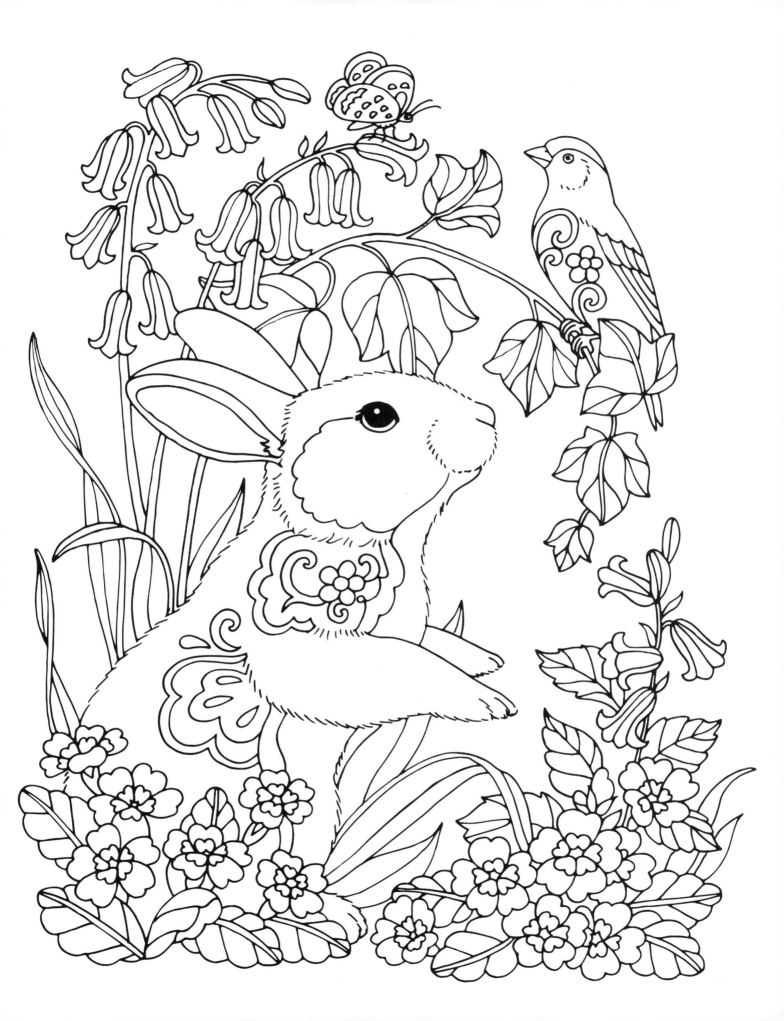

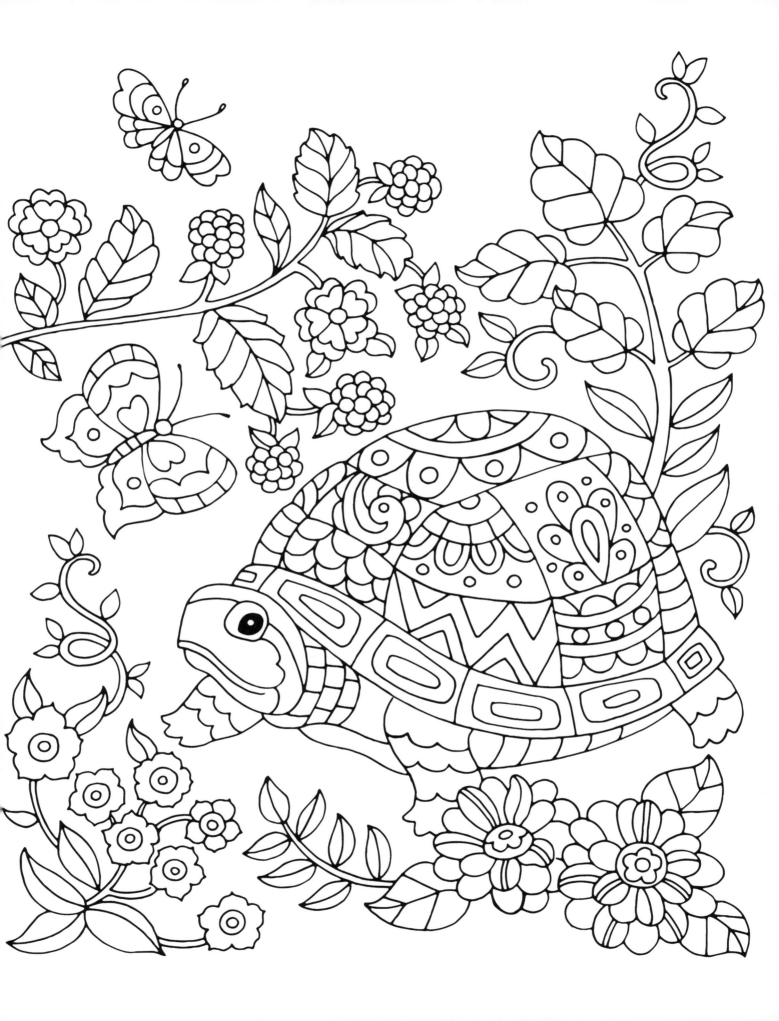

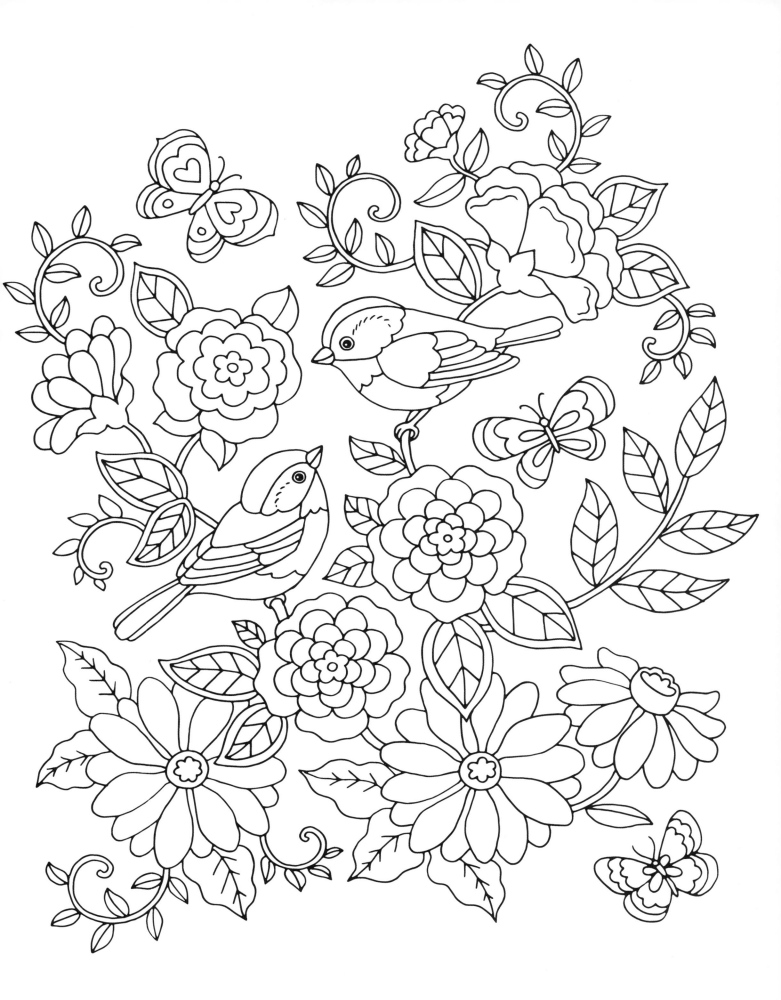

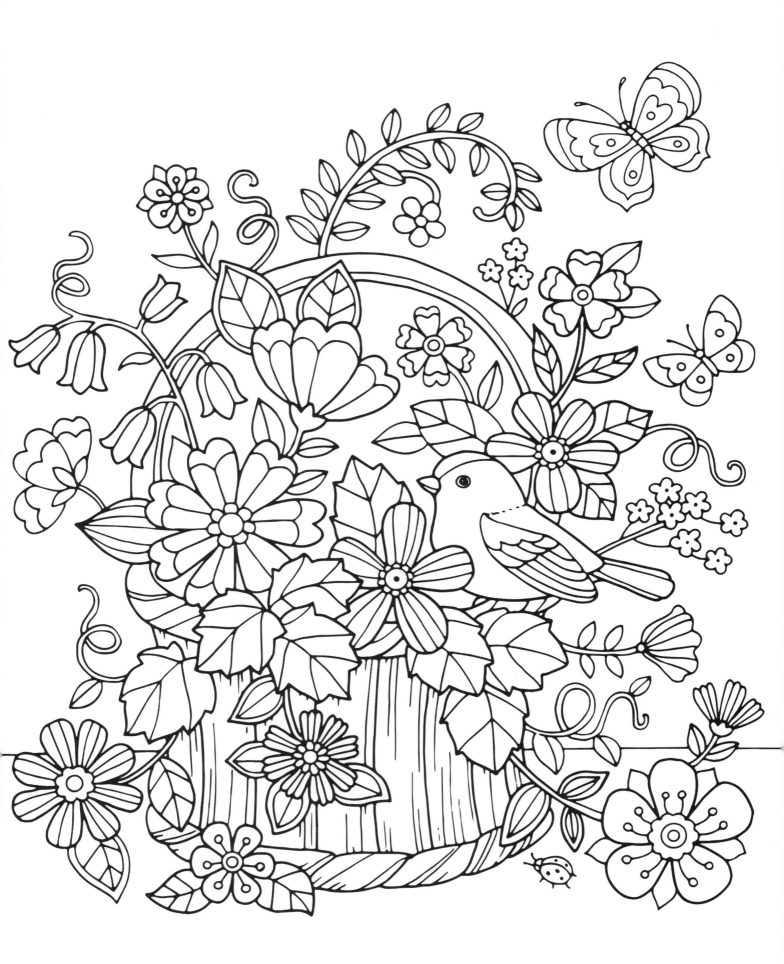

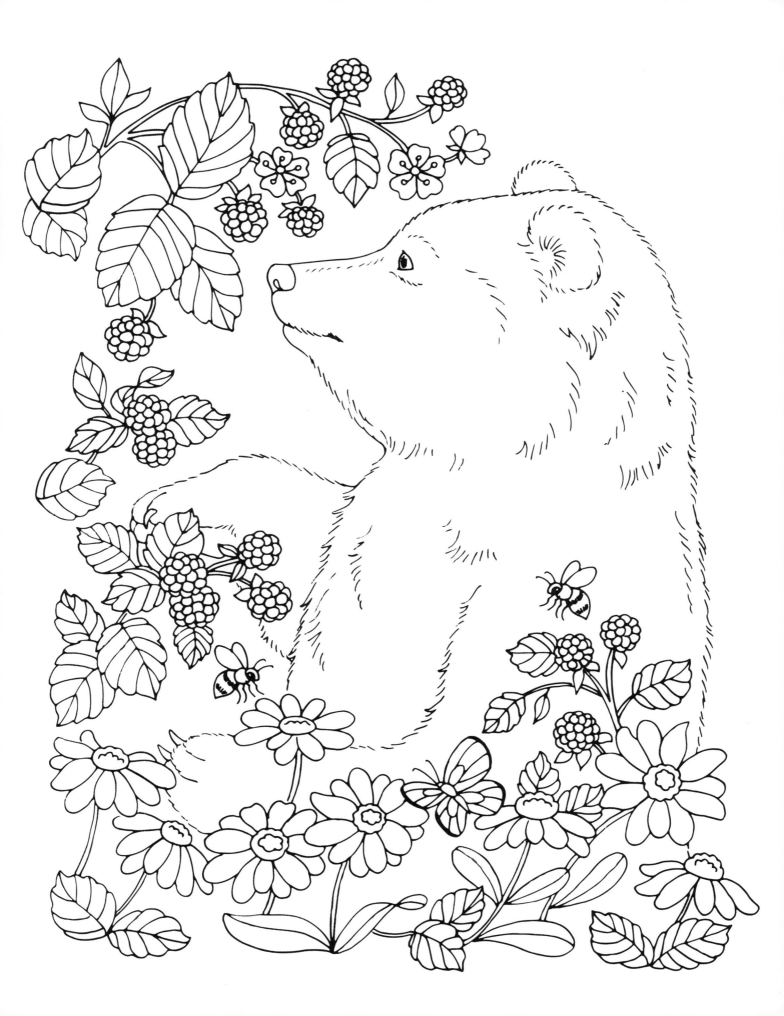

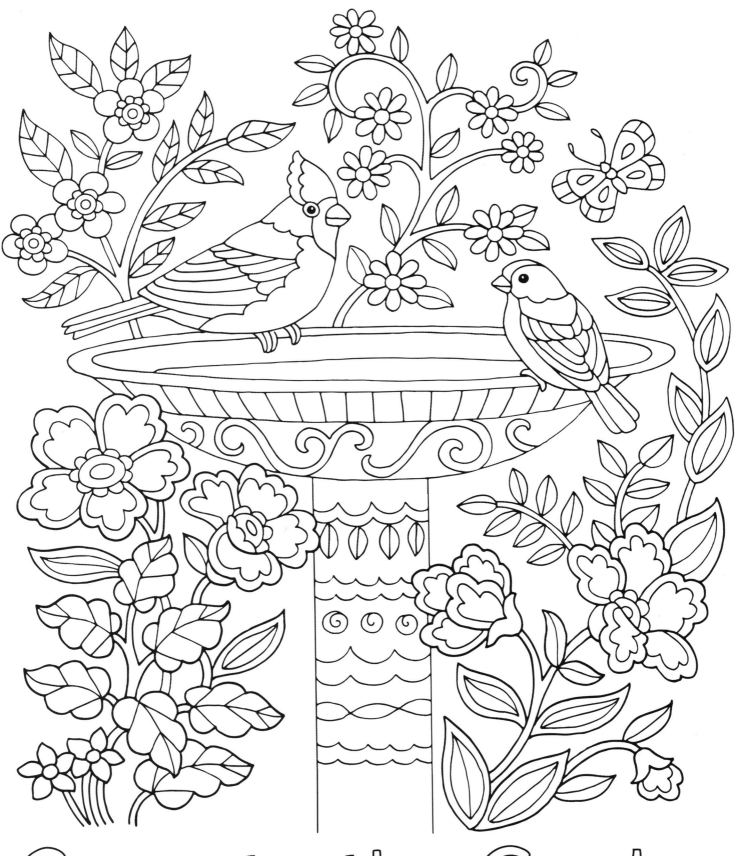

Come to the Garden

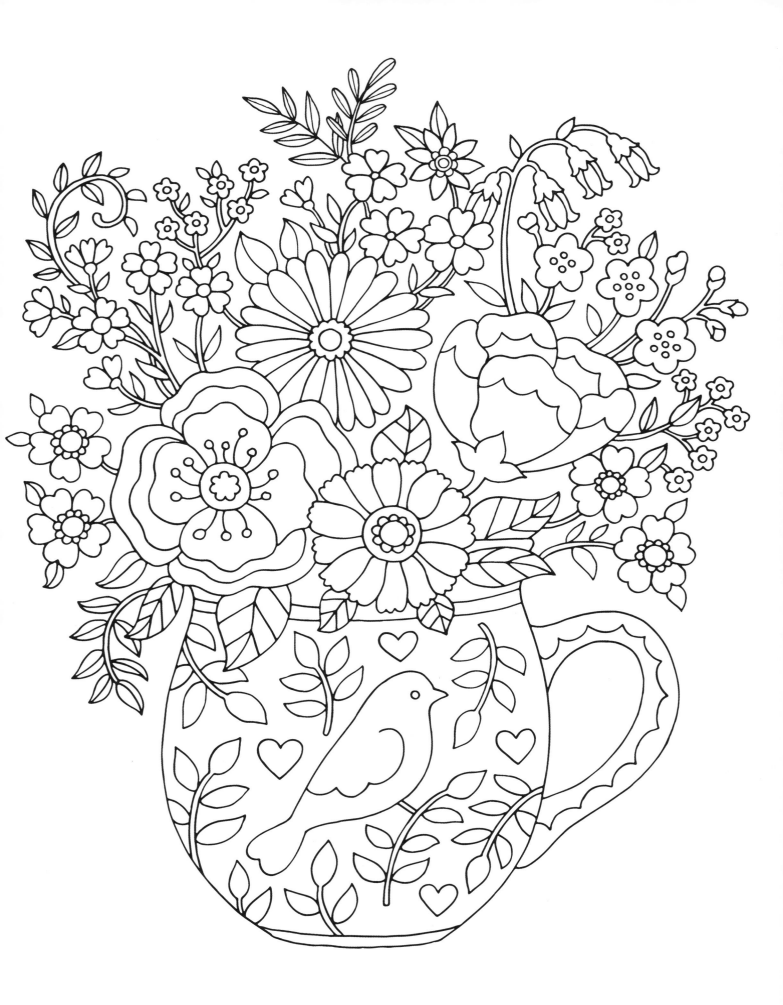

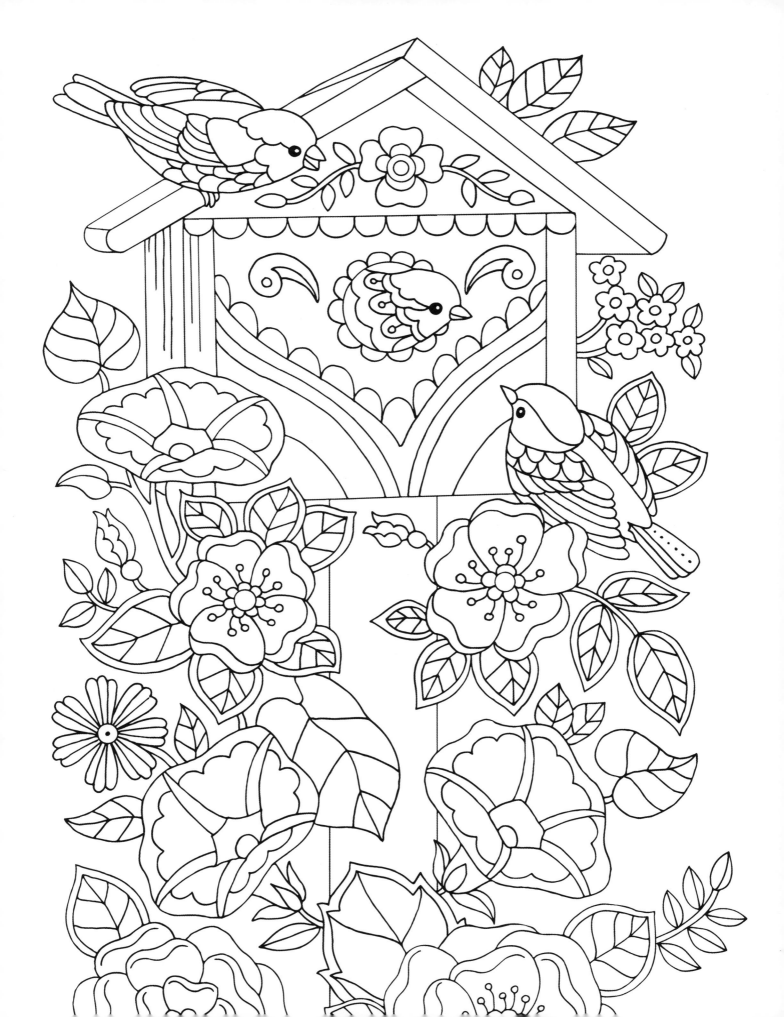

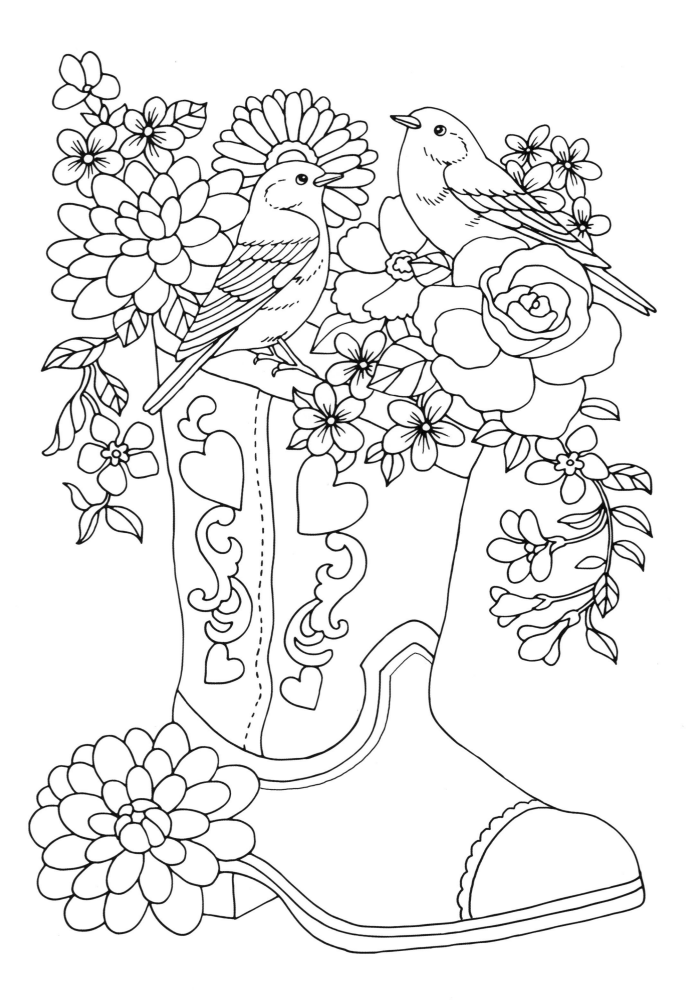

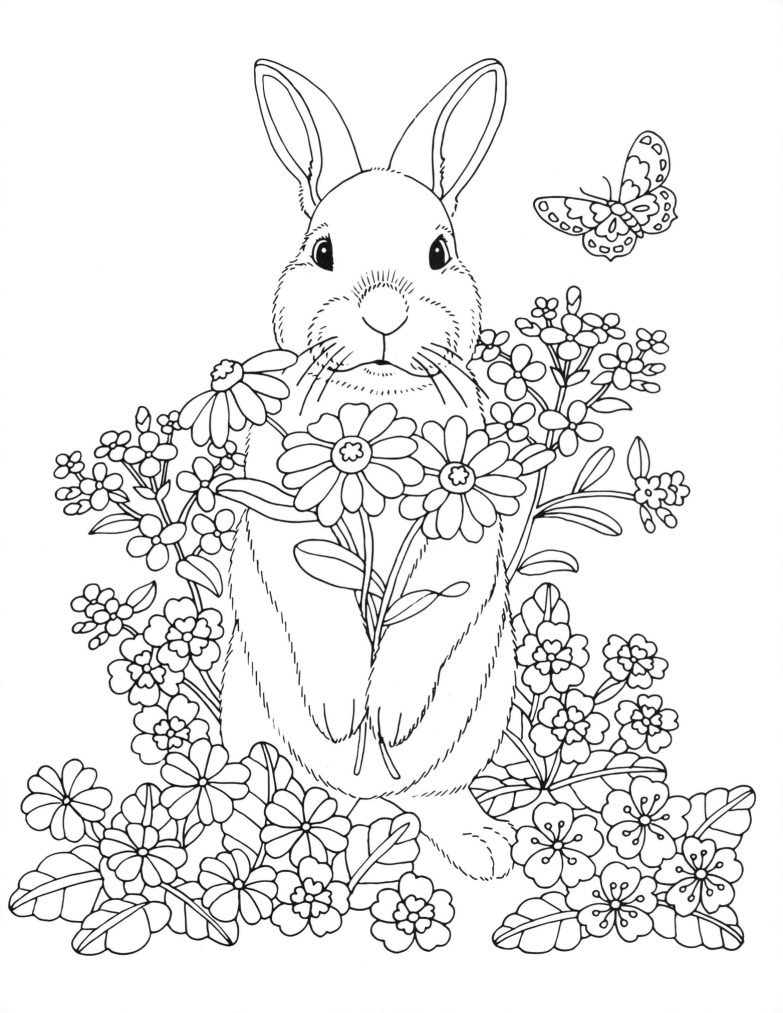

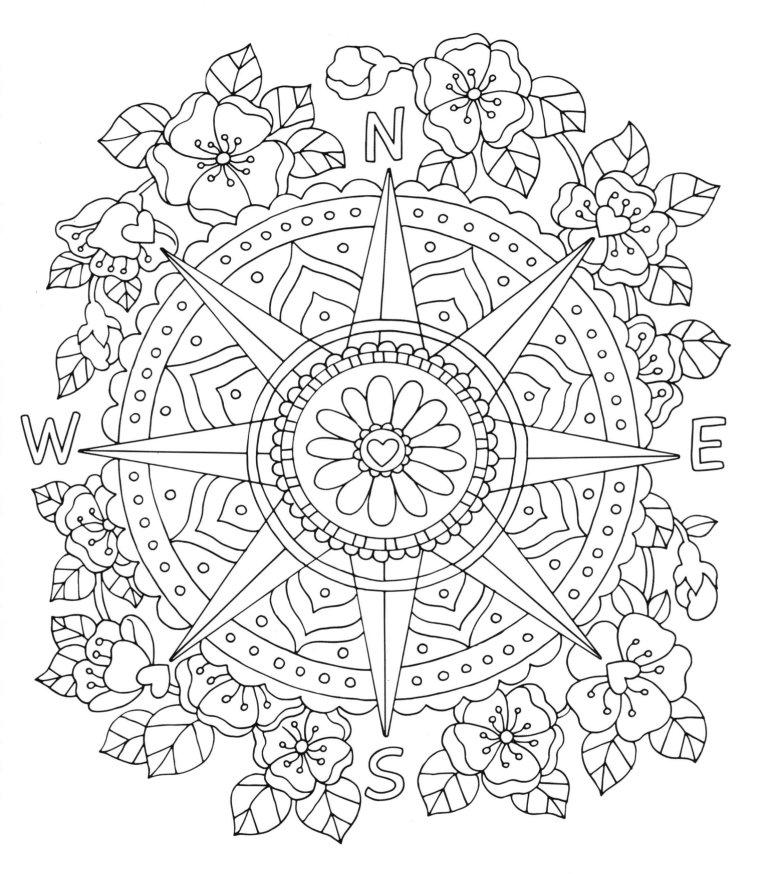

FOLLOW YOUR HEART

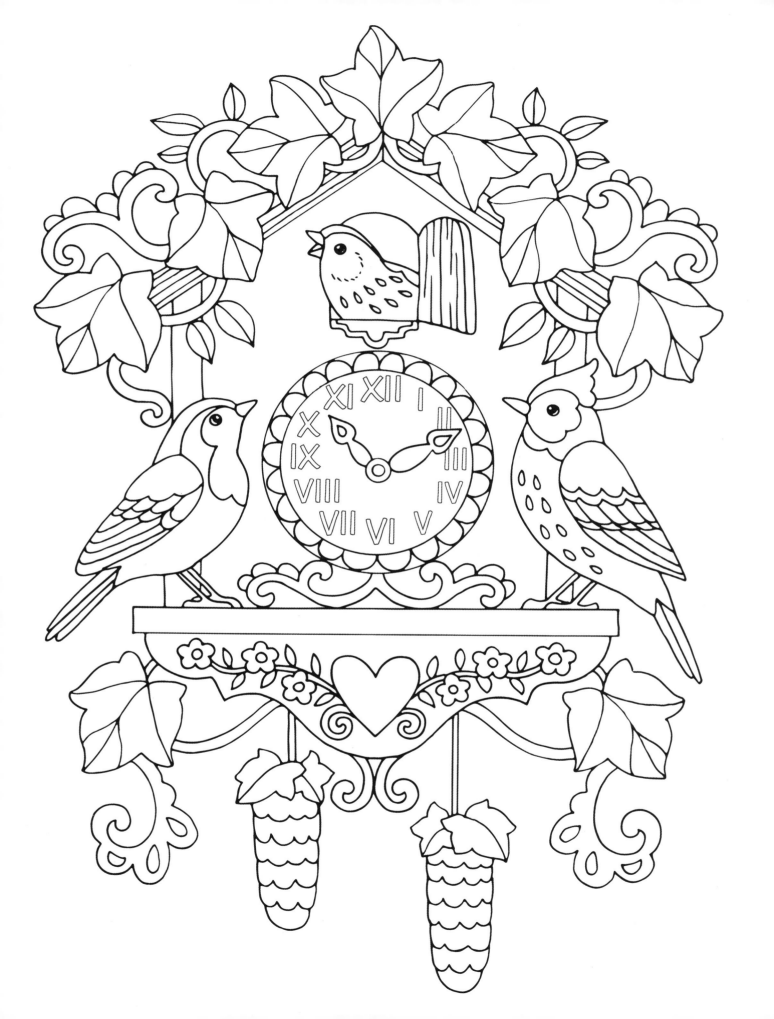

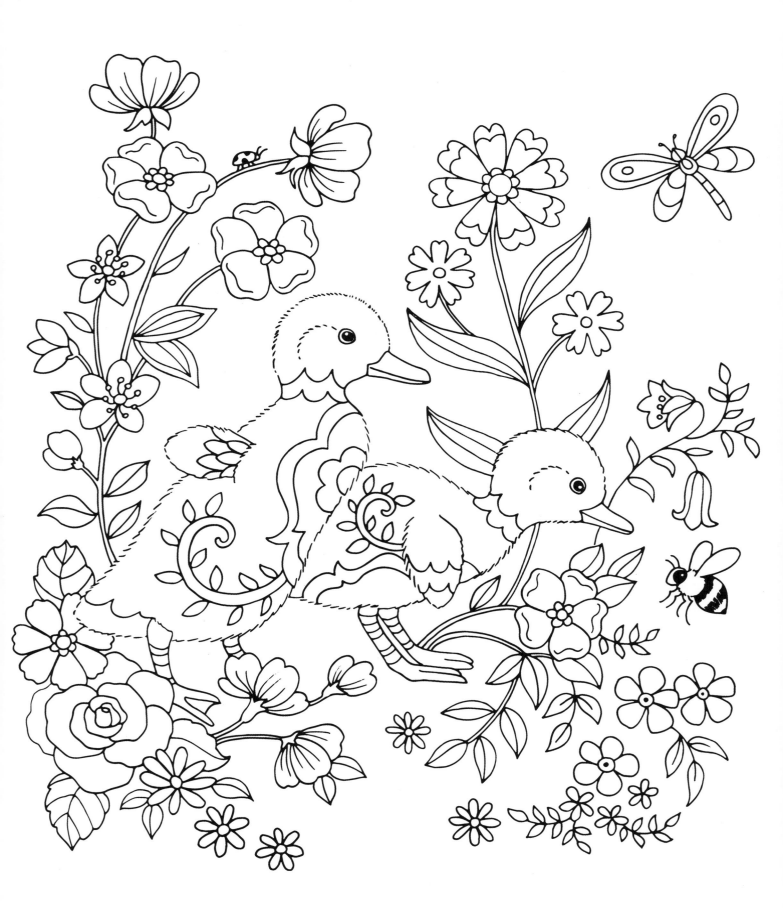

FARMER'S MARKET

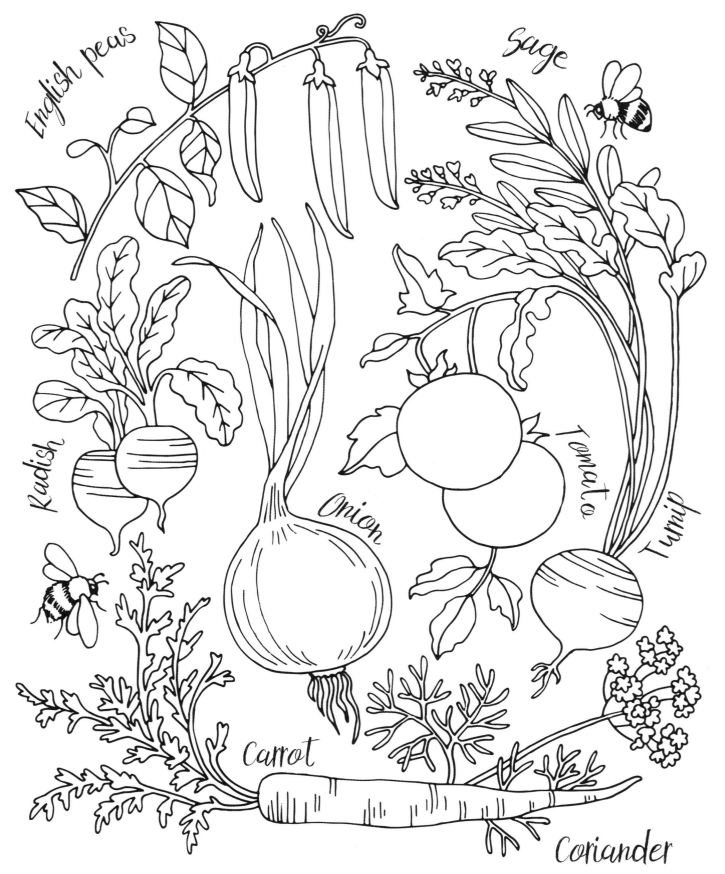

English peas

Sage

Radish

Onion

Tomato

Turnip

Carrot

Coriander

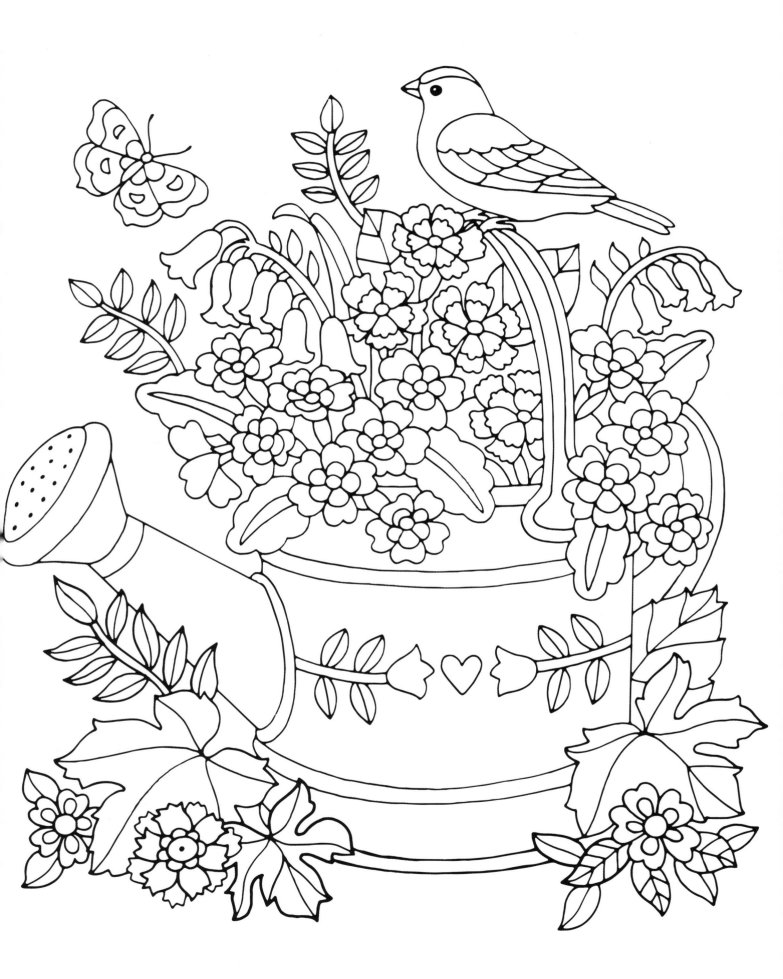

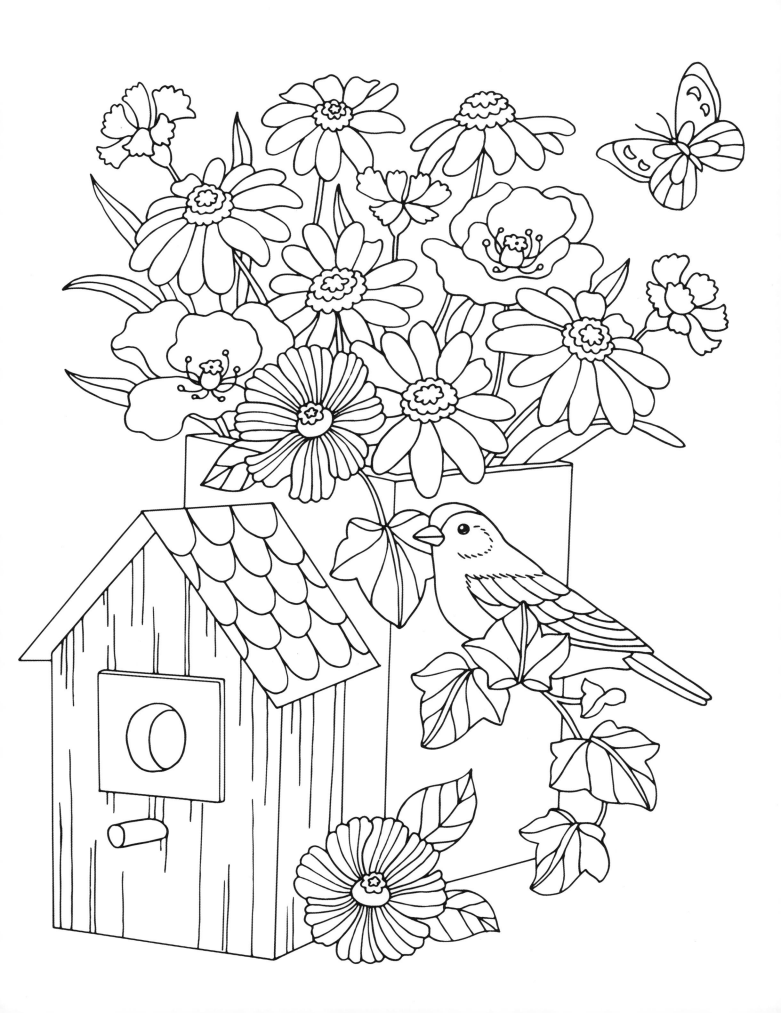

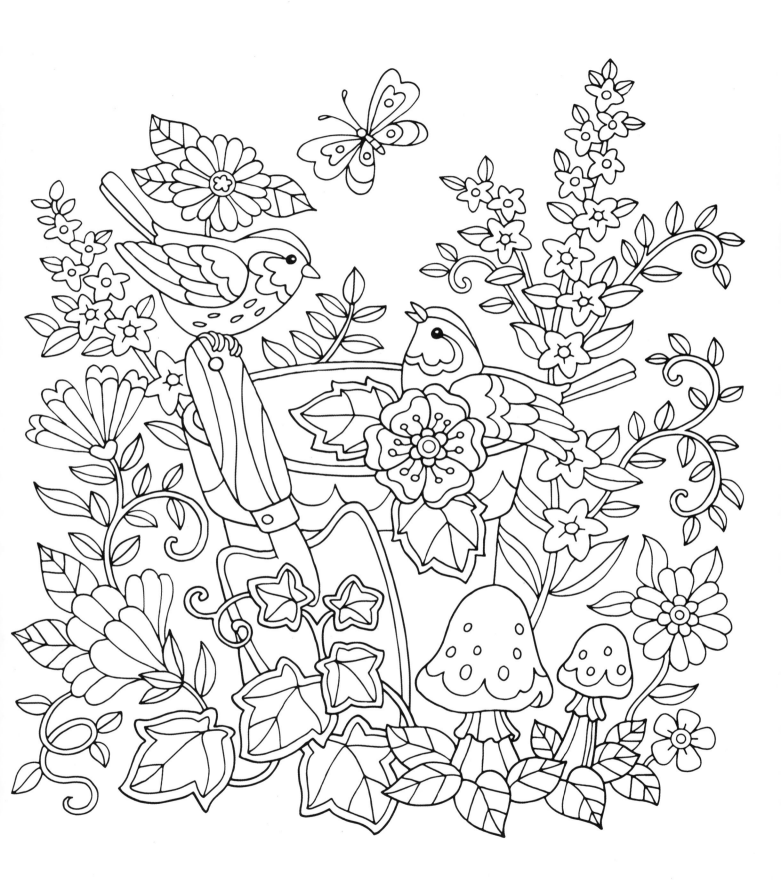

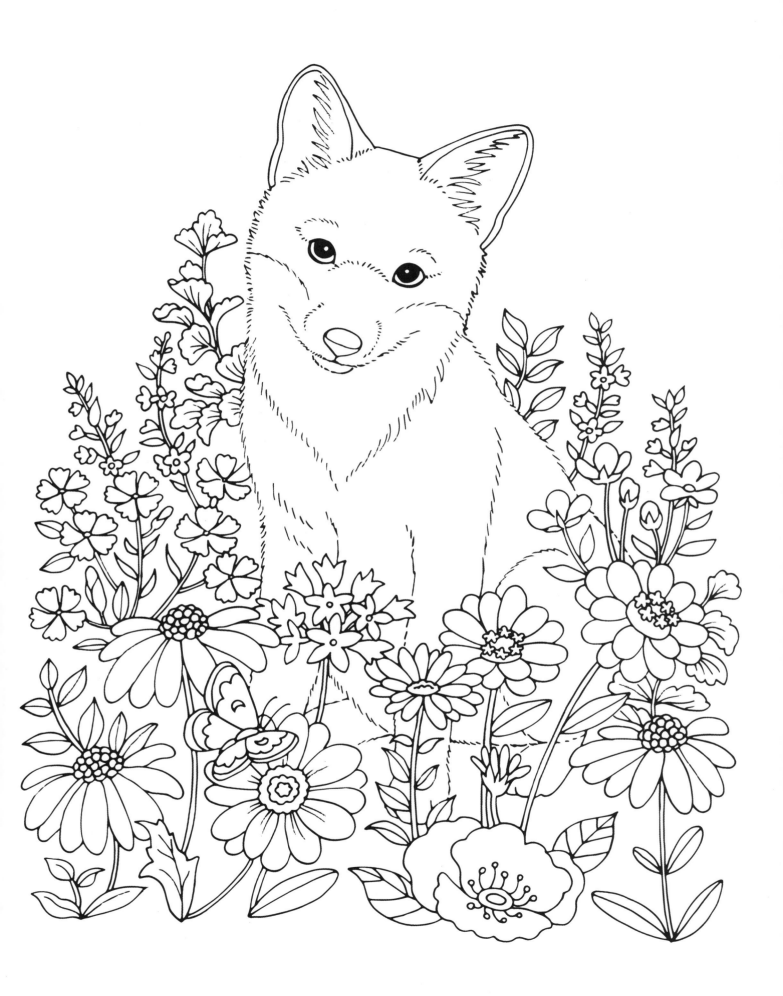

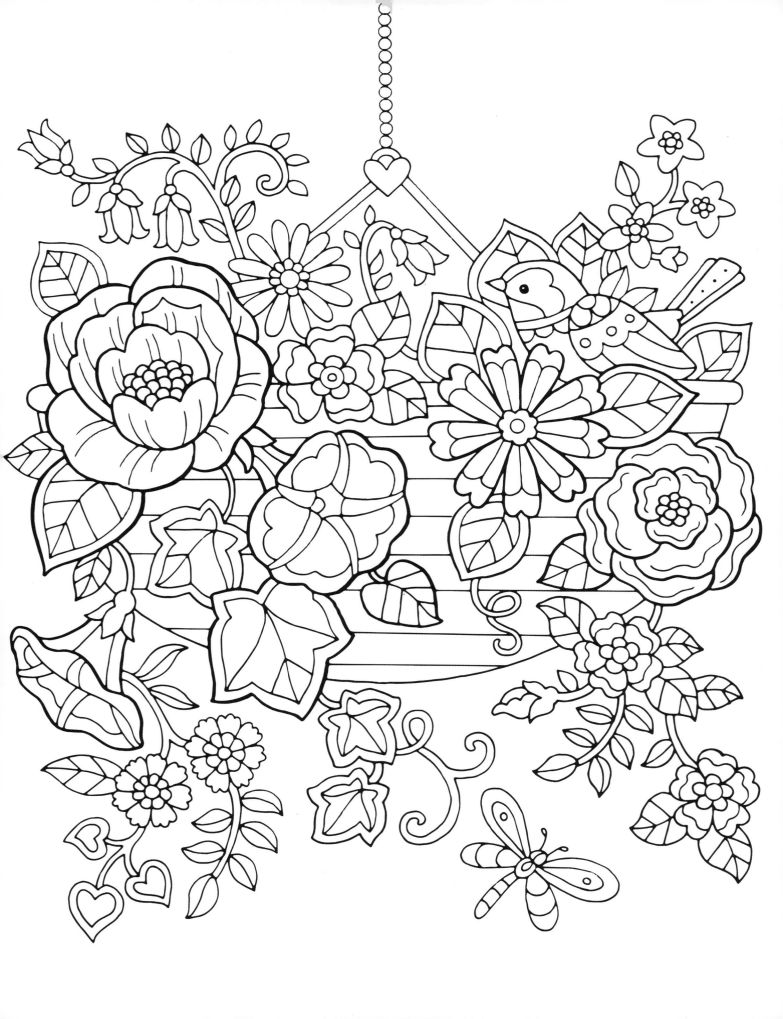

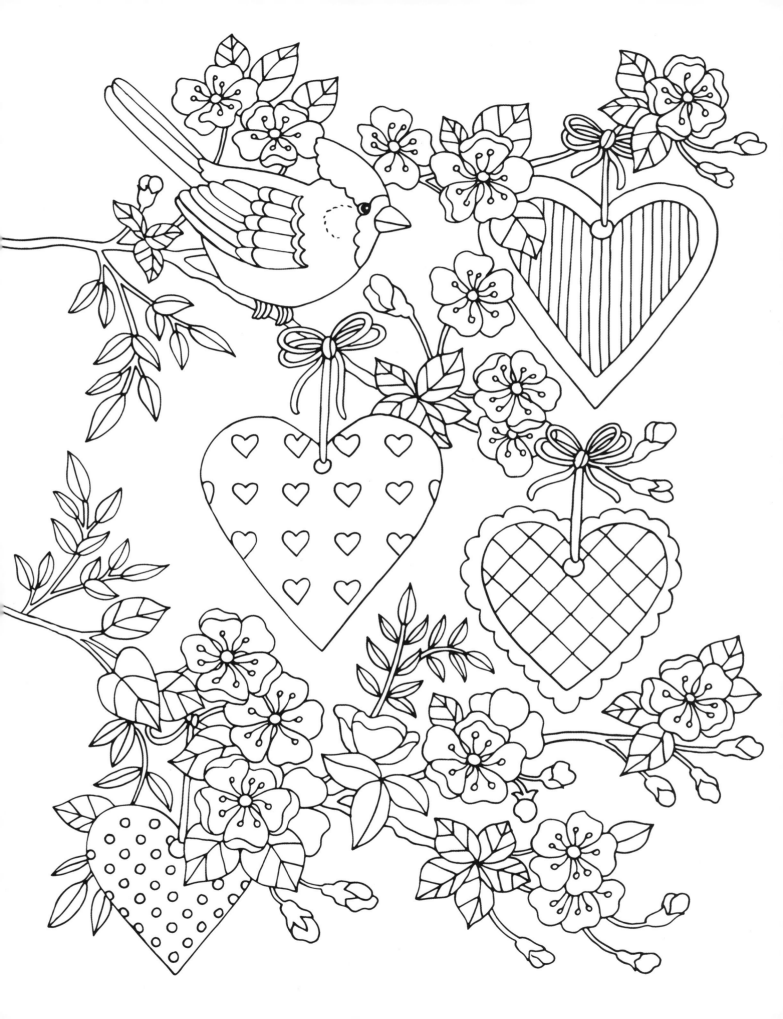

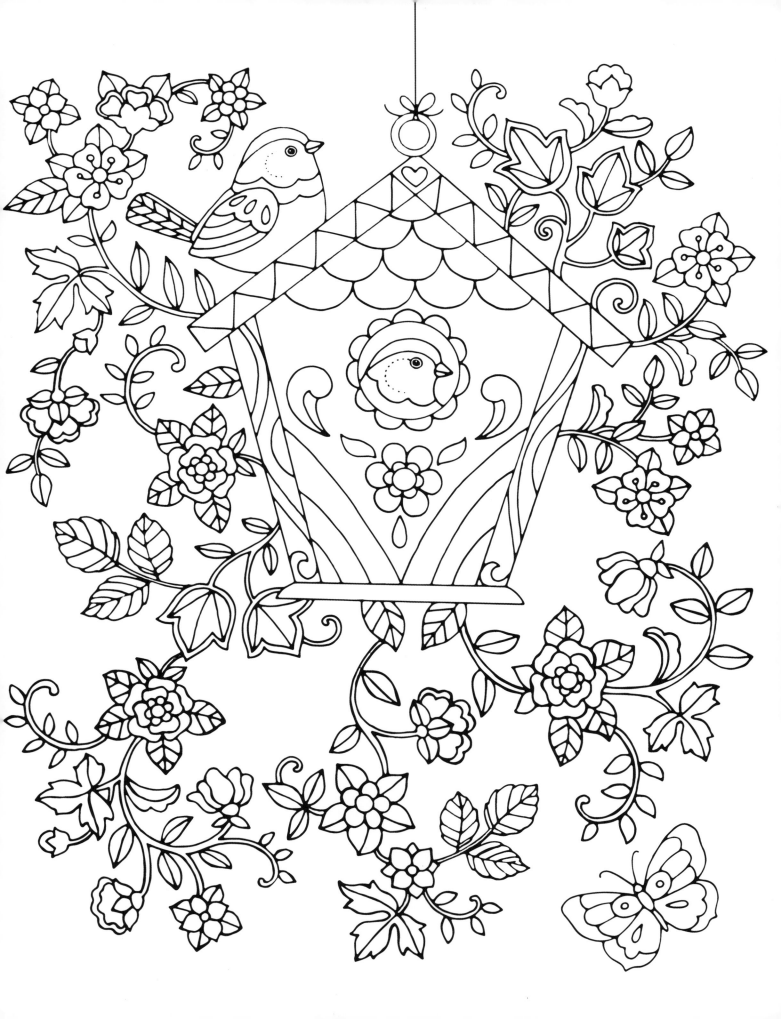

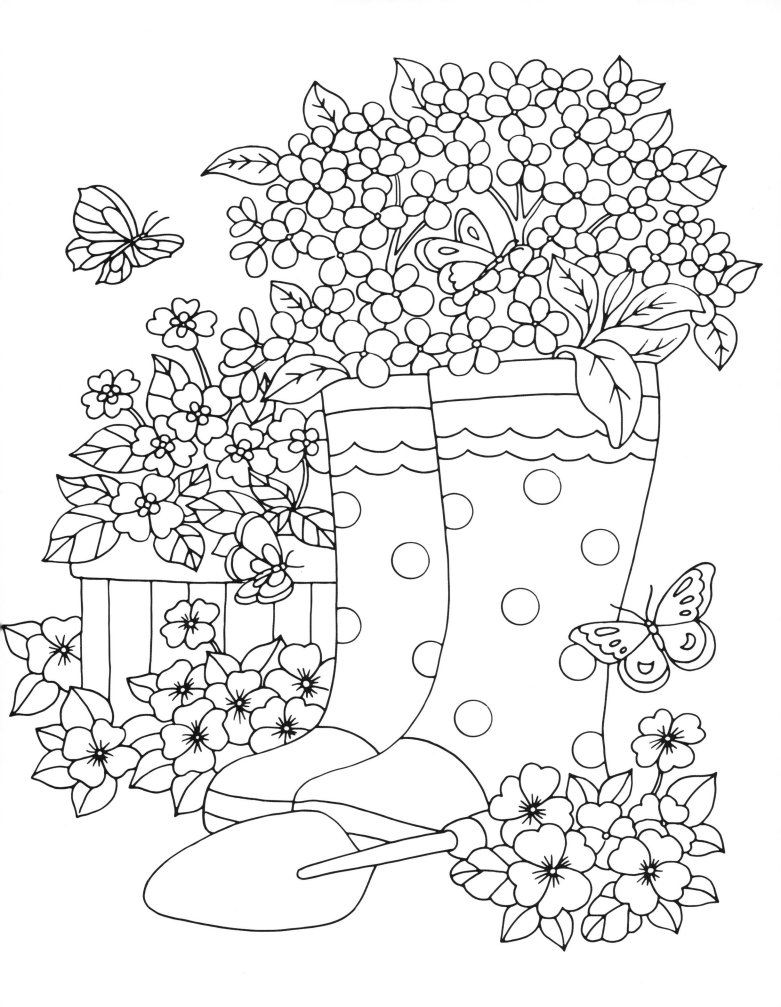

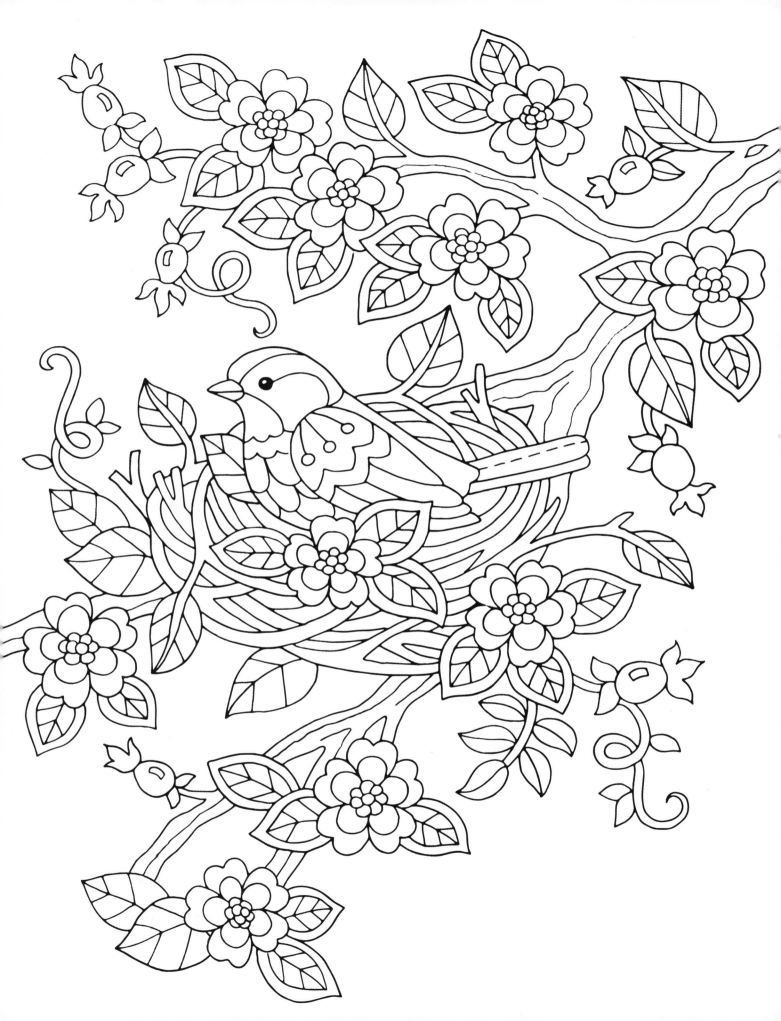

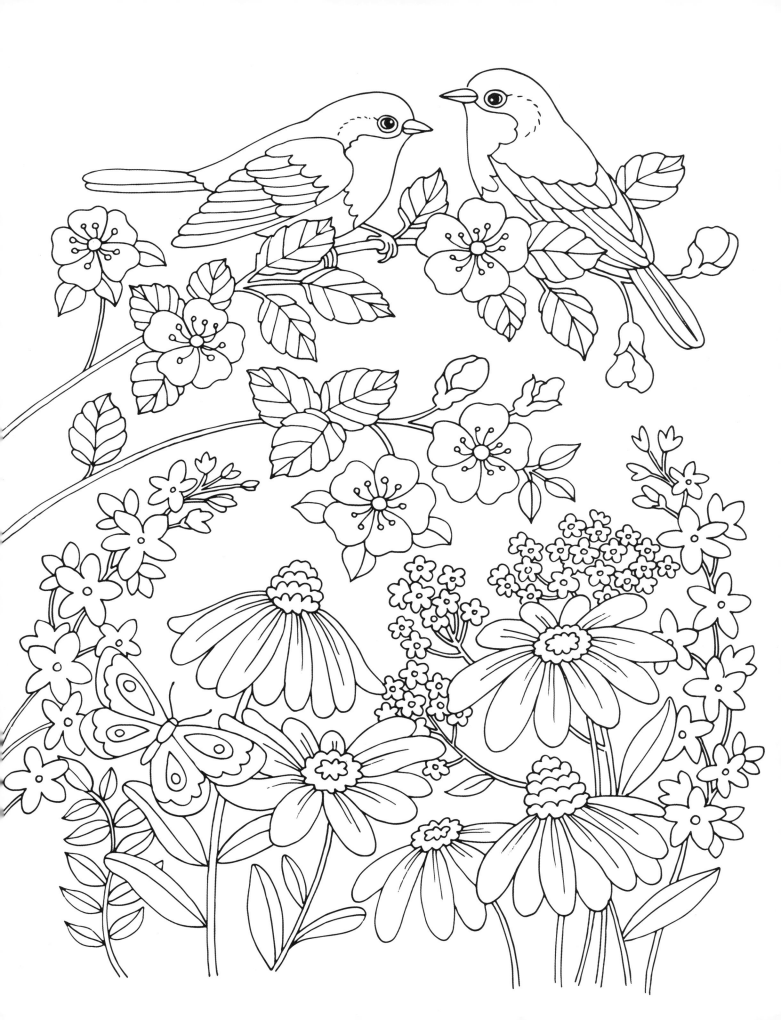

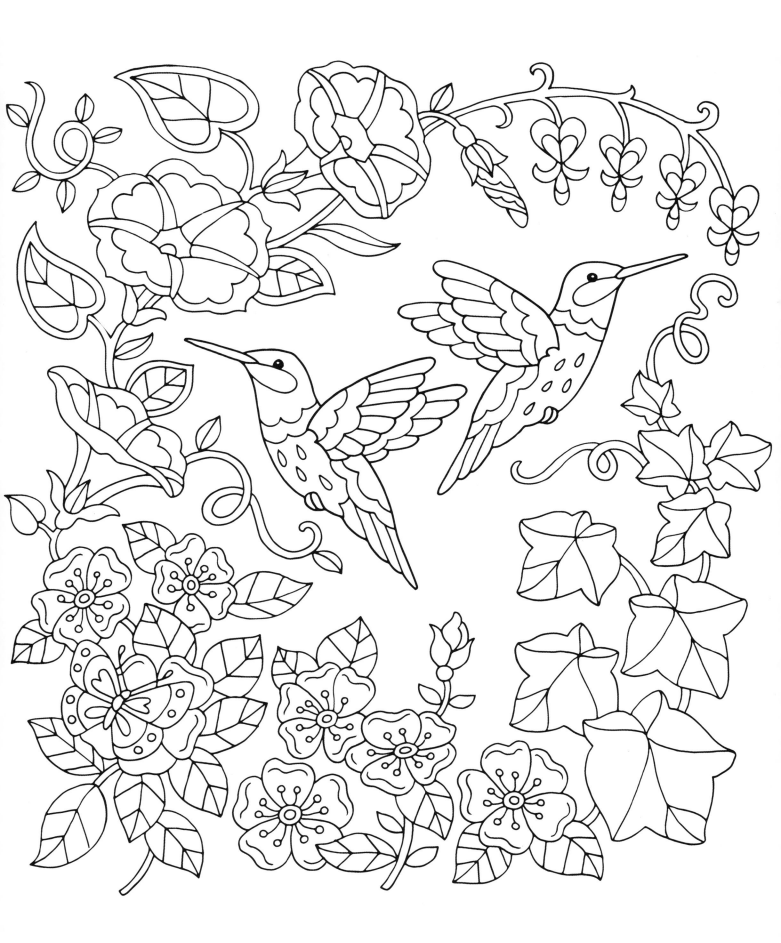

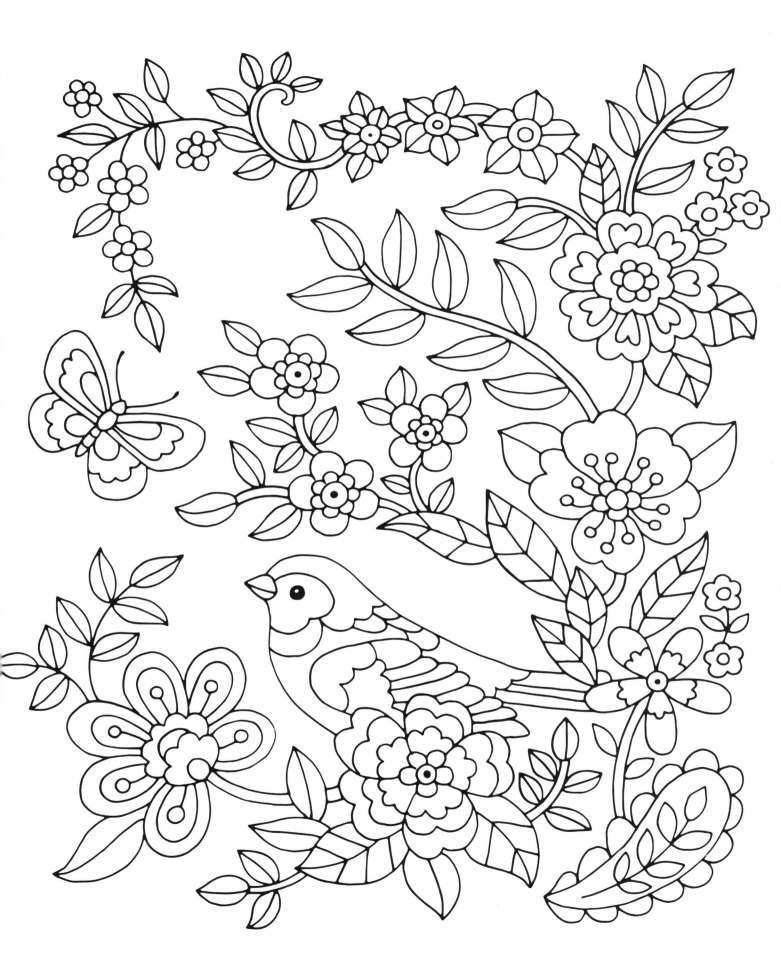

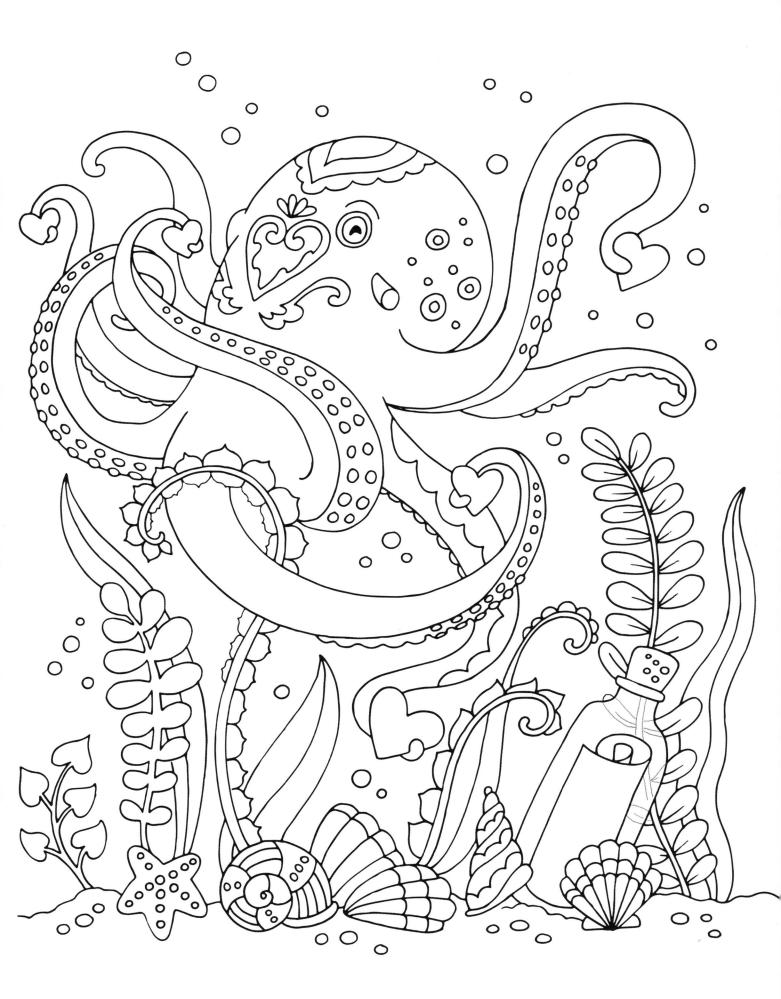

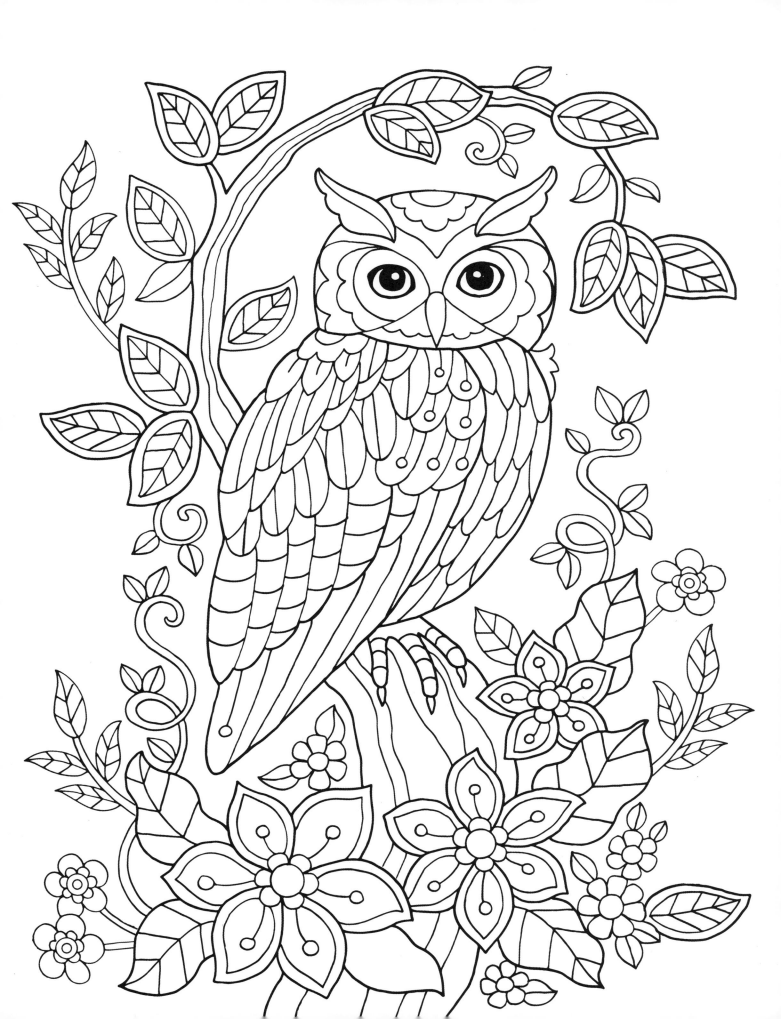

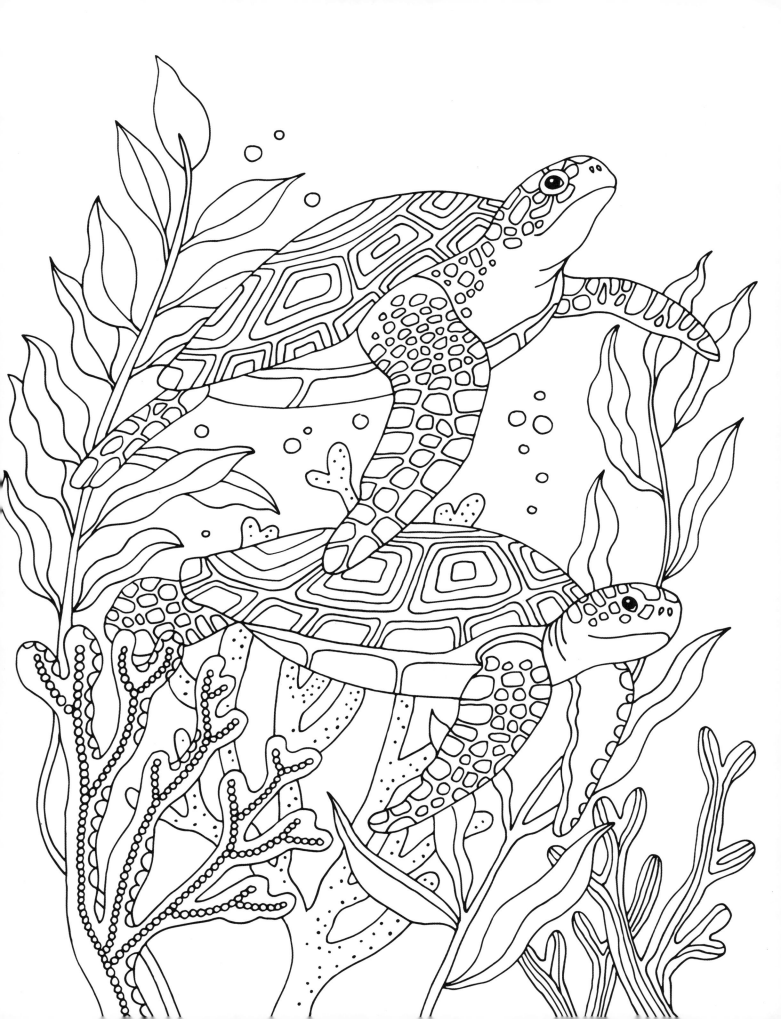

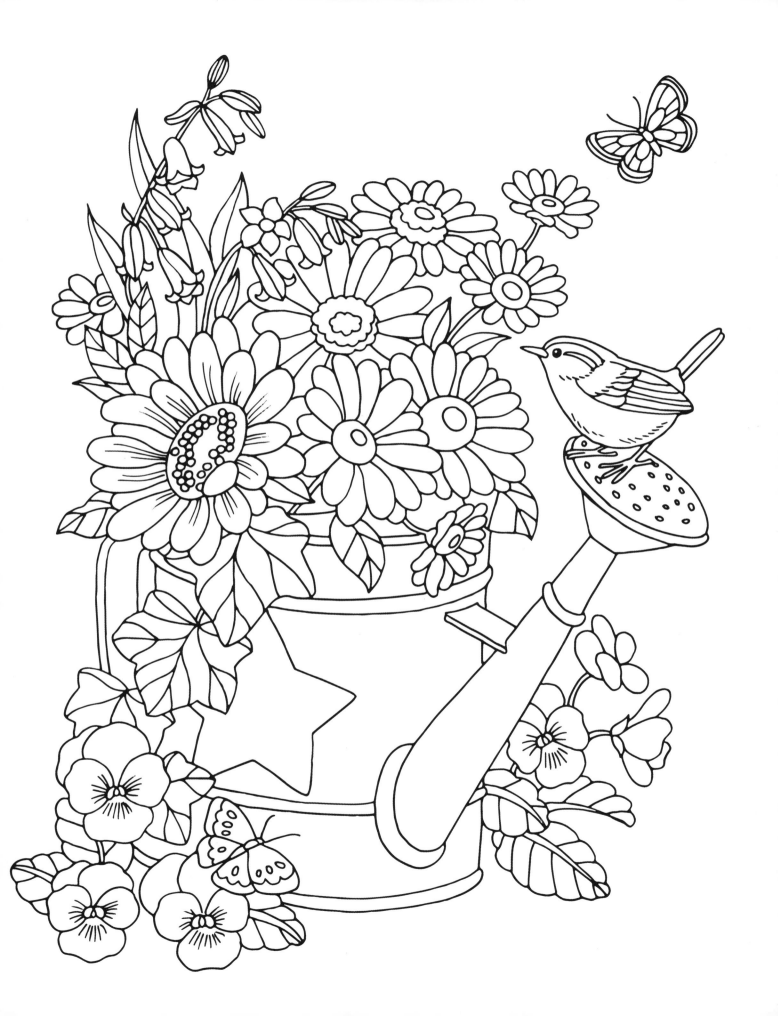

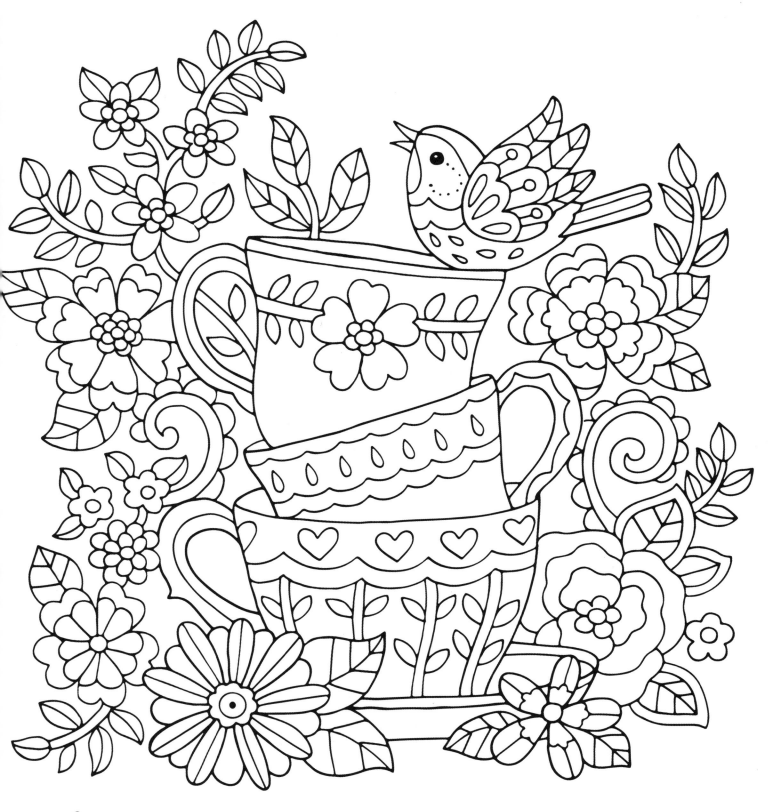

It's always time for tea

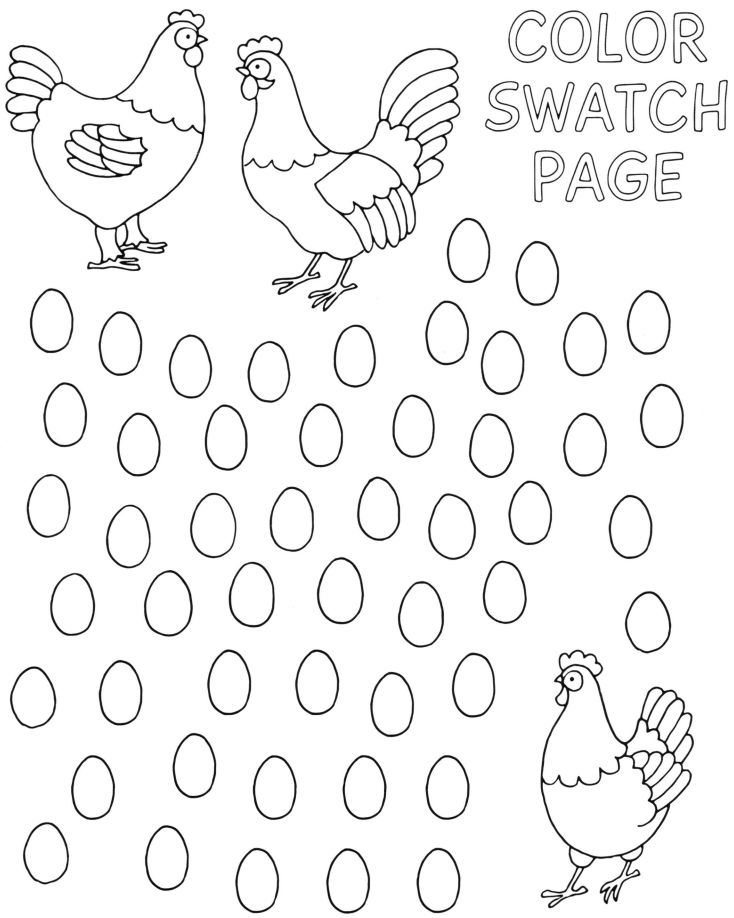

COLOR
SWATCH
PAGE

Use this page to try out the colors of your markers and pencils. Sometimes
the actual color can differ from the color on the barrel of the pencil.

This book is for Margaret, who will always be my coloring buddy.

Get Creative 6

An imprint of Mixed Media Resources
19 West 21st Street, Suite 601
New York, NY 10010
sixthandspringbooks.com

Editor
PAM WISSMAN

Art Director
IRENE LEDWITH

―――――――――――――――――

Chief Executive Officer
CAROLINE KILMER

President
ART JOINNIDES

Chairman
JAY STEIN

Manufactured in China

9 10

First Edition

About the Author

Jane began her career at fourteen years of age, as a scientific illustrator for the University of Florida. After receiving a bachelor's degree from the Ringling College

of Art and Design, she was recruited by Hallmark Cards, Inc. as an illustrator. Jane left the corporate world after her children were born, and moved to beautiful Colorado. Her work has adorned dozens of books, collector plates, ornaments, cards, T-shirts, garden flags, jigsaw puzzles, and many more. In addition to the breathtaking Colorado landscape, she has two children, a menagerie of animals, a garden for inspiration, and a husband to share it all.

Thanks to Pam and the SoHo team for their support and hard work!